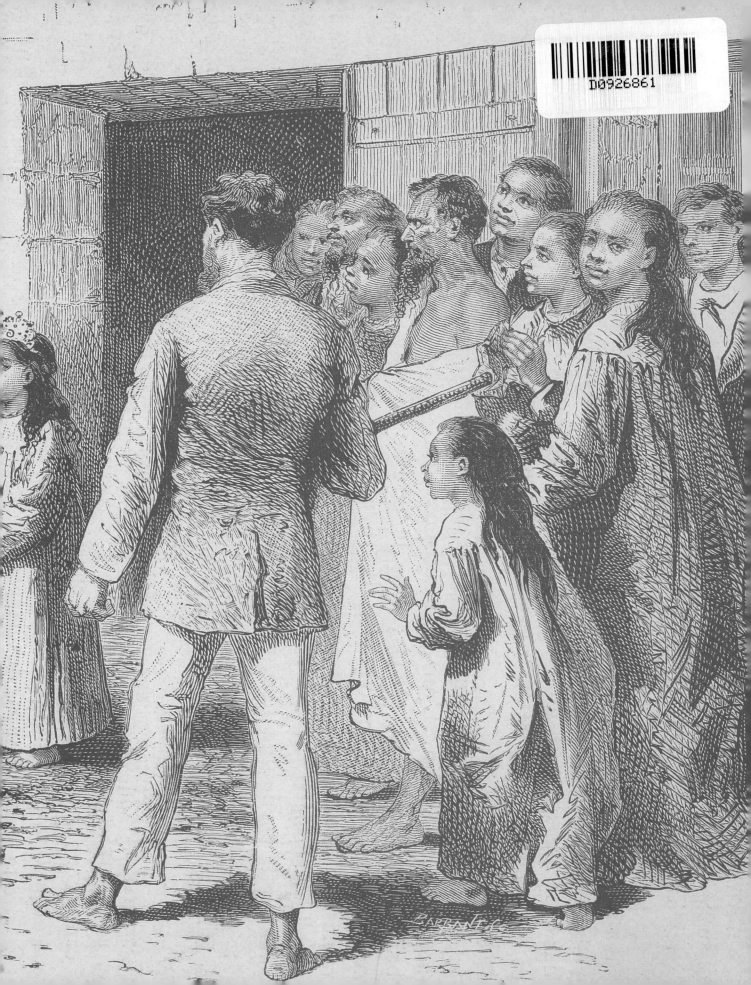

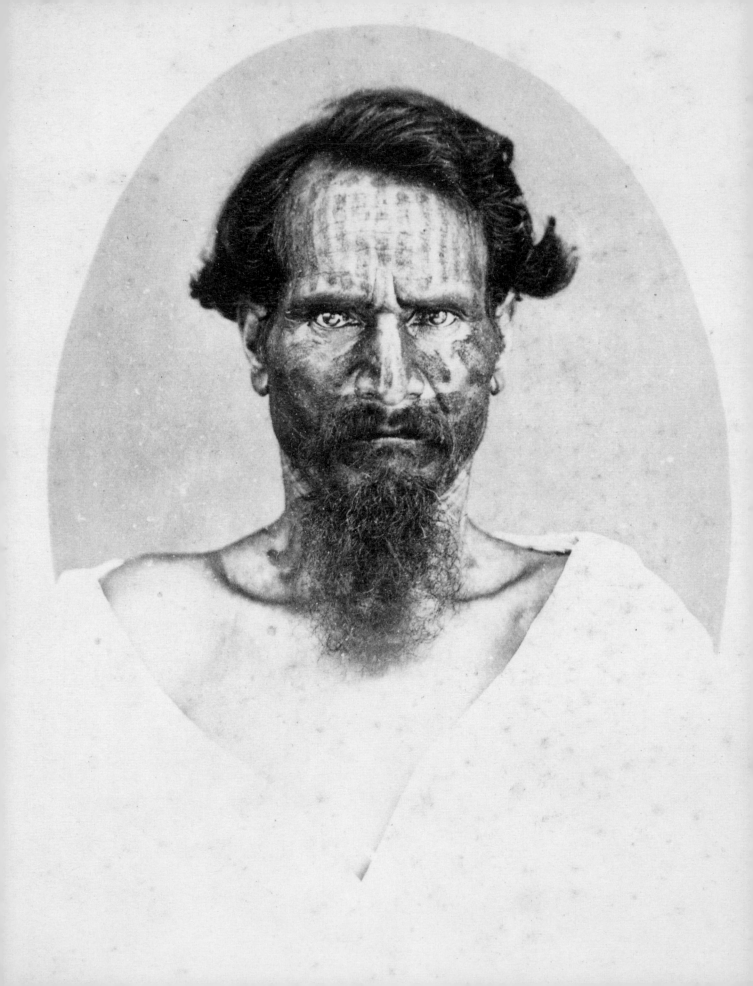

Adrienne L. Kaeppler and Jo Anne Van Tilburg

The Iconic

TATTOOED MAN

of Easter Island

AN ILLUSTRATED LIFE

MANA PRESS

Rapa Nui coastline near Cook Bay
(detail of Figure 14, pp. 10–11).

PREVIOUS PAGES

P. I
Tattooed Man in the crowd at Mataveri
during the meeting of Alphonse Pinart
and Pua 'Aku Reŋa ko Reto (detail of
Figure 22a, p. 20).

FRONTISPIECE, P. II
Carte de visite of the Tattooed Man.
Madame Hoare, Tahiti, 1870s.
Mark and Carolyn Blackburn Collection,
Los Angeles County Museum of Art.

CONTENTS

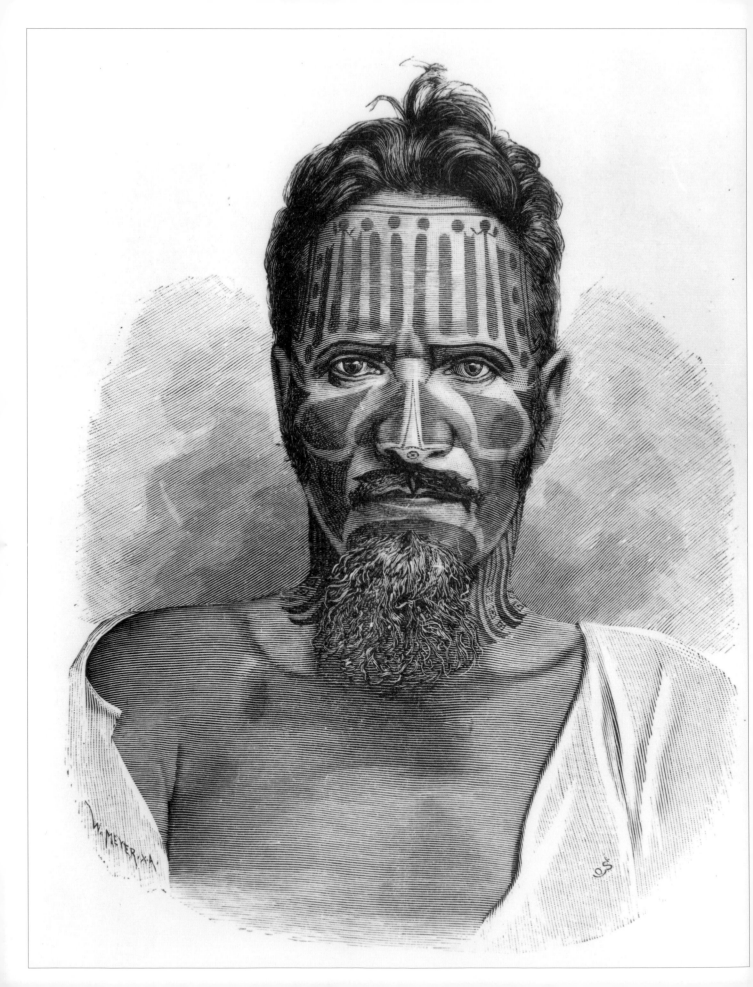

In many parts of Polynesia, tattoo is a major identity marker, often associated with social status and puberty rites. The extent, complexity, and symbolism of Polynesian tattooing is related to the individual's rank, relationships, and ability to reward the tattoo artist. The most elaborately tattooed individuals are of the highest status. Archaeologists have documented tattoo implements in Polynesia that date back as early as AD 1000–1300. Westerners first depicted Polynesian tattoo during the Pacific voyages of Captain James Cook in the late eighteenth century. Tattooing became a repressed art with the coming of missionaries to Polynesia in the nineteenth century. Many Polynesians subsequently embraced some of the old forms and creatively adapted tattoo to modern tastes. During the late twentieth century, tattoo regained its importance, and today it has come into prominence as a major art form.

An impressively tattooed Easter Island (Rapa Nui) man appears often in the pages of Pacific Island history books and museum catalogs. His frank countenance belies the mystery that surrounds his identity.[1] The Swedish ethnographer Dr. Knut Hjalmar Stolpe knew him only by his baptismal name, Tepano (Stolpe 1899, 4). We refer to him here as the Tattooed Man. Tepano, the Tahitian version of the Christian name Stephen (in Latin Stephanus, in Spanish Esteban), was a name given to many newly baptized islanders. What is the Tattooed Man's real Rapanui identity, and what can his life story tell us about the history of Easter Island?

In these pages, we reveal who he was, who illustrated him, and how he transcended the tragic events of nineteenth-century Rapa Nui to become one of the best-known, most iconic faces of the Polynesian past. To provide context for our identification, we summarize the history of tattoo as practiced by Rapanui experts (*maori*), link that history to island geography, analyze the changes some artists made to their field drawings of tattooed individuals, and present further documentation of rare barkcloth sculptures collected from 1839 and the 1840s that provide a visual record of tattoo patterns.

FIG. 1 (OPPOSITE) AND FIG. 2 (P. VIII)
Tattooed Man known as "Tepano."
Photo engravings, Wilhelm Fredrik Meyer and Carl Olof Sörling (in Stolpe 1899, 4).
Smithsonian Institution, photographs by Donald E. Hurlbert.

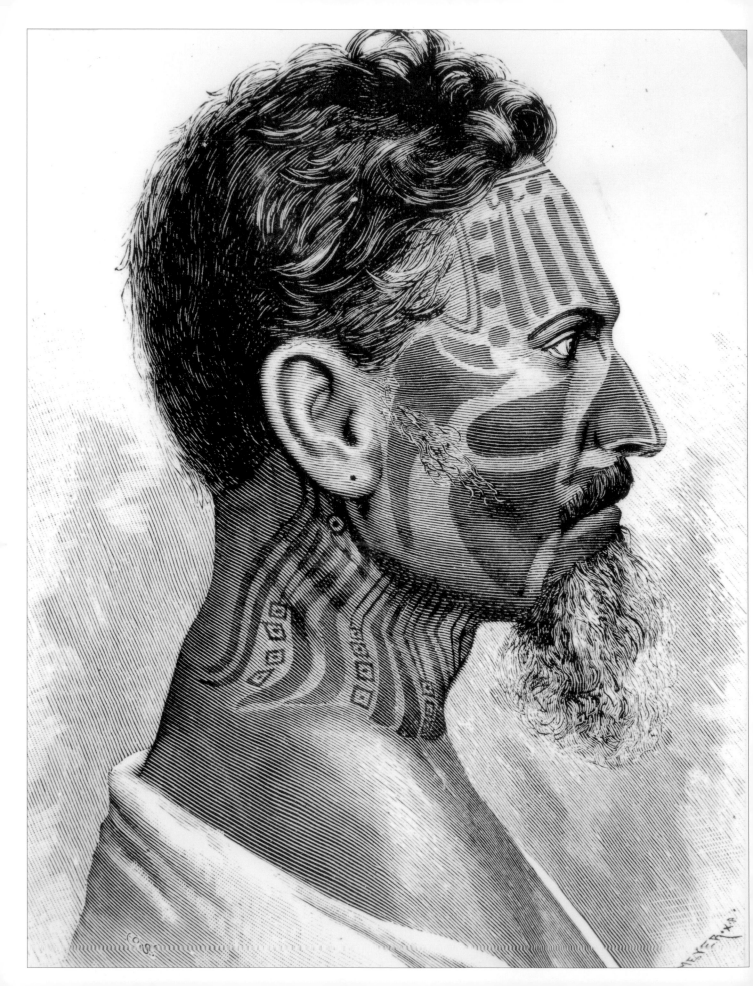

THE TATTOOED MAN

Tepano was a common name among baptized Rapanui males in the 1860s. It is in our day the surname of a large Rapanui family, one branch of which includes the famous ethnographic consultant known today as Juan Tepano Rano (born ca. 1876; commonly called Parare'e and hereafter referred to as Juan Tepano).[2] The prominence in Rapanui society of Juan Tepano, along with the frequent appearance of his name in the published literature, has led some writers and researchers to mistakenly conflate his identity with that of the Tattooed Man (see note 1).

Stolpe published two illustrations of the Tattooed Man (Figures 1 and 2), both of which are signed W. Meyer, indicating that they are the work of the xylographer Wilhelm Fredrik Meyer (1844–1944). The initials O. S., also on both illustrations, identify Carl Olof Sörling (1852–1927), then illustrator for the Royal Swedish Academy of Letters, History, and Archaeology. Kaeppler published an undated carte de visite photograph of the Tattooed Man taken in Tahiti by Madame Sophia Hoare (Frontispiece, p. ii; Kaeppler 2001, 38, Fig. 18). We have subsequently discovered three additional, previously unpublished photographs of the Tattooed Man. The first is an undated, front-facing studio portrait attributed to Oscar Elkholm, a photographer who traveled with Stolpe (Figure 4). The second is a poor-quality black-and-white right-profile print with no attribution other than "Hawaii," which is incorrect because, as we establish below, both photos were taken in Tahiti of the same person (Figure 3).[3] As Stolpe notes, "I photographed him front and side."[4] The third photo, also a poor-quality black-and-white print, depicts an unnamed Rapanui man in left profile (Figure 5). It is annotated

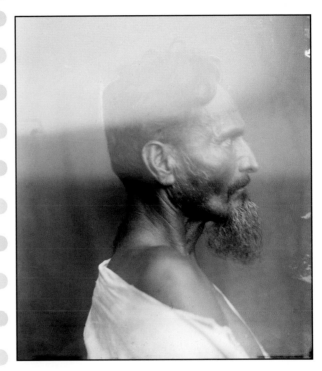

"Easter Island" and "Tattooed Man," and was taken by one of the photographers of the U.S. Fish Commission steamer USS *Albatross* (Agassiz 1913, 425–30).[5] Although he is almost clean-shaven in this photo, his tattoos are difficult to see, but we believe that this is the same man Stolpe met in Tahiti.[6] Stolpe described the Tattooed Man as "a good-looking, rather strong man with a high forehead, a sparkle in his eyes, an eagle-nose, and an unusually strong beard."[7] He worked in Pape'ete harbor at the docks and in the warehouses—which put him at the nexus of Tahiti's maritime connections with Rapa Nui.

FIG. 3 (ABOVE)
Profile of Tattooed Man.
Photograph, Hjalmar Stolpe and Oscar Elkholm,
Tahiti, undated (1884?).
Etnografiska museet, Sweden.

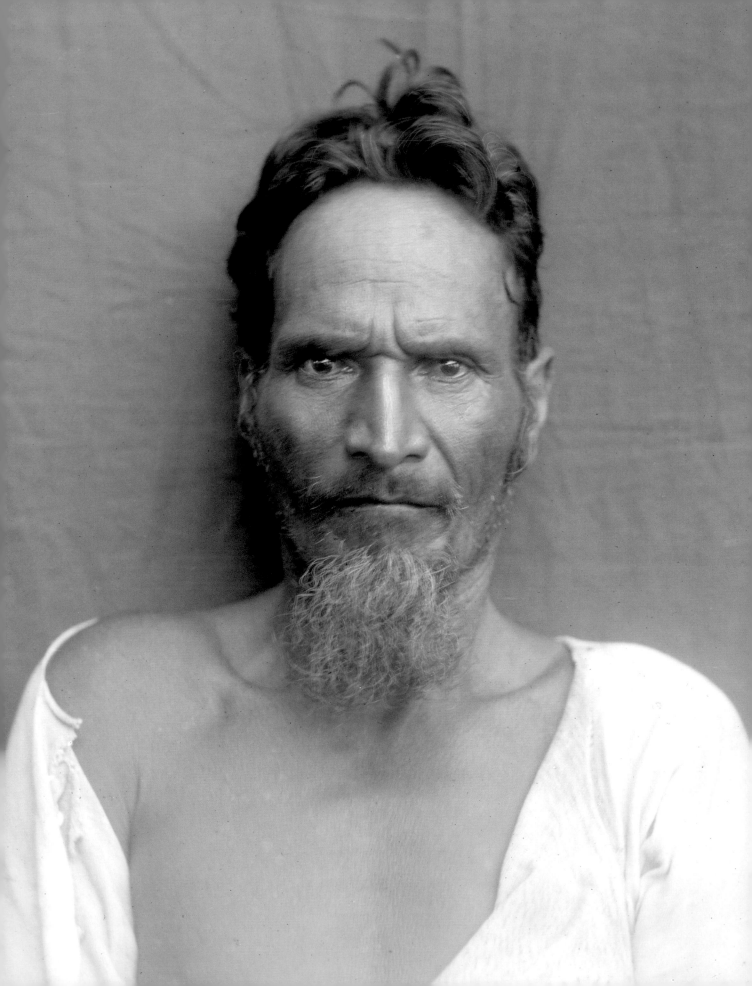

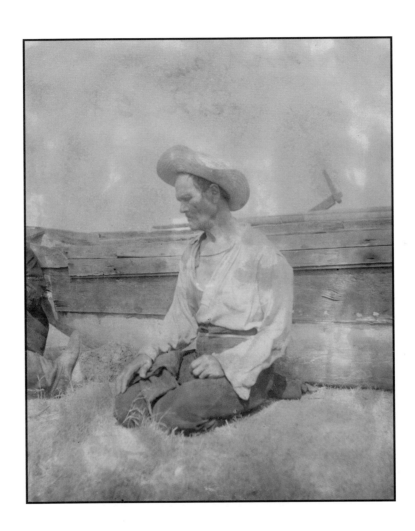

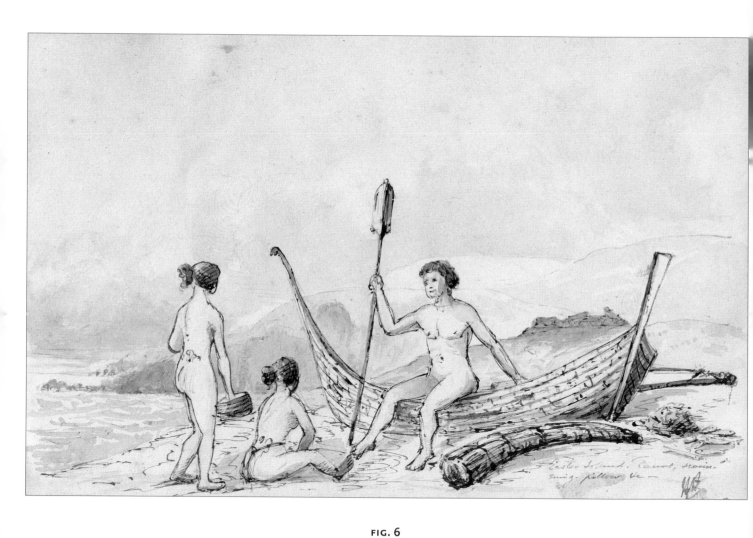

FIG. 6
Three young Rapanui with body art.
Ink and wash drawing over pencil,
John Linton Palmer, HMS Topaze, *1868.*
Royal Geographical Society (with the Institute
of British Geographers), London.

THE TATTOOED MAN AND HOA HAKANANAI'A

RAPA NUI, NOVEMBER 1868

The Tattooed Man bore historically important tattoos beyond his facial one. He also had a roughly incised tattoo on his forearm memorializing the 1868 removal of the statue Hoa Hakananai'a from Oroŋo by the crew of HMS *Topaze* (Figure 7).[8] Stolpe notes:

The most interesting tattooing, whereby this Tepano became a living chronicle of Easter Island, was located at the right lower arm. On top near the elbow joint, is a roughly sketched human figure, without legs, tattooed transversely over the arm. From its center a straight line runs to the wrist held by ten small human figures. To the one side of these there is a large figure, leaning on a staff, and to the other side there is a somewhat smaller one. When asking for the significance of this picture script, Tepano gave the surprising answer, that it represents the dragging down of one of the large stone statues of Easter Island to the beach. The ten people, pulling on the rope, are "English sailors," the large man with the staff is the "First Officer," the other one the "Second Officer." The small figure, which is standing on the lying statue, is a dancing tribal chief.[9]

The occurrence, which Tepano immortalized in his tattooed skin, was supposed to have been "about fifteen years before."[10] It therefore can only pertain to the statue Hoa Hakananai'a, now in the British Museum, which in the year 1868, as described by Dr. J. Linton Palmer, the physician on the English warship *Topaze*, was brought to Europe. Tepano confirmed this assumption with his immediate recognition of the name Palmer.

The drama implicit in the pain of incising the underside of one's right forearm to commemorate a historical event suggests that the Tattooed Man was present at the event and had a meaningful connection to the statue. We assume that he tattooed himself and was left-handed. The statue, in turn, is linked ethnographically to Oroŋo and its *taŋata manu* ("birdman") religion, as well as to coming-of-age rituals and the island's higher-ranked western sociopolitical group, Ko Tu'u Aro Ko Te Mata Nui (map, p. 44).[11] The Miru kin group, named for the second son of Hotu Matu'a, the island's founding ancestor and paramount chief (*ariki mau*), dominated the Tu'u. The royal estates were established in the 'Anakena and Ovahe area. The eastern district is named for Hotu Iti, the youngest son of Hotu Matu'a.[12] It contains Rano Raraku, the statue quarry, and is dominated by Ahu Toŋariki, the largest ceremonial site.

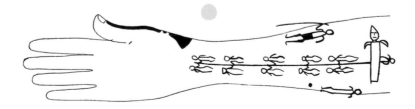

FIG. 7
Tattooed Man's arm with Hoa Hakananai'a tattoo, line drawing by Stolpe (1899, Fig. 10).
Smithsonian Institution,
photograph by Donald E. Hurlbert.

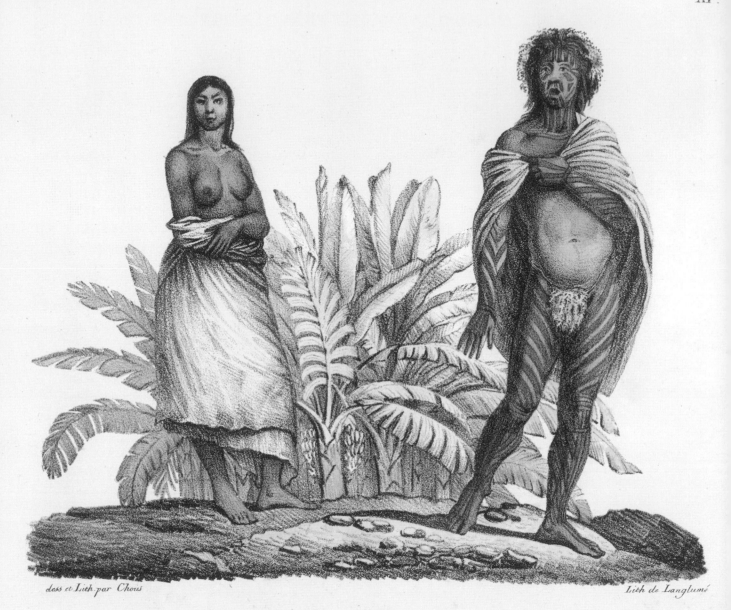

XI

dess et Lith par Chöris

Lith de Langlumé

Habitans de l'île de Pasques.

FIG. 8
Habitans *[sic]* de l'île de Pasques.
Lithograph after drawing by Louis Choris, 1822.
National Library of Australia, ABN 28346858075.

THE GEOGRAPHY OF RAPANUI TATTOO

EARLY ILLUSTRATIONS, LOCALES, AND KEY PEOPLE

The first of only five eighteenth-century calls Europeans made at Rapa Nui occurred in 1722, when a Dutch ship under Captain Jacob Roggeveen landed in the vicinity of the Miru, somewhere in the region spanning 'Anakena and Ovahe to Heki'i (Corney 1908). The Dutch remarked on but did not illustrate the vibrant body art (painting and tattoo) displayed by the men and women they encountered there.[13]

The first known depictions of a tattooed Rapanui person are two 1774 preliminary studies by William Hodges, the official artist on Cook's second voyage (Figures 10a and 10b). His subject was a woman seen somewhere between Haŋa Roa and Vinapū or, less likely, along the coast between Vaihū and Akahaŋa. He depicts her with a line-and-dot motif on her forehead and curvilinear designs on her left cheek. An engraver refined her likeness, and the resulting image became widely known (Figure 11). From 1774 onward, most European ships called at Cook's anchorage, which came to be known as "Cook Bay," "Baie de Captain Cook," or "Cook's Bay" (Figure 14; Kaeppler 2010, 3). The bay is large, with deep coves, and fronts the coastal area between Haŋa Roa and Mataveri. Europeans visiting the same vicinity subsequently encountered all the tattooed Rapanui people we discuss here.

In 1795, Captain Charles Bishop of the *Ruby*, out of Bristol, depicted unusual geometric and marine tattoo or painted patterns (Roe 1967). He sketched a Rapanui man with upper body art and a Rapanui woman named Te'ree with facial and upper body art, both of whom boarded ship in Cook Bay (Figure 9).[14] In 1815, Captain Otto von Kotzebue anchored the *Rurick*, a ship of the Russian Imperial Navy, and encountered "men with painted faces."[15] Louis Choris (1795–1828), the official artist of the voyage, depicted a Rapanui man and woman at Cook Bay (Figure 8; Chauvet 1945). The woman in Choris's drawing does not appear to be tattooed, but the man's body art is elaborate. He has tattooed arms, hands, legs, and feet, and his clavicle, neck, and face are decorated in motifs that, while difficult to fully discern, resemble those of the Tattooed Man.

In 1827, the English naturalist Hugh Cuming called at Cook Bay aboard his yacht, *Discoverer*.[16] Approximately

FIG. 9
Tattooed Rapanui man and woman with trade items.
Watercolor, Captain Charles Bishop, Ruby, 1795.
Royal British Columbia Museum and Archives,
IMAGE I-61916.

50 Rapanui people boarded, and Cuming commented on their tattoos, although he did not depict them. He observed that "both Sexes are tatoo'd, each sex differing from each other." He noted red and black body paint and men with "Lips Dye'd Blue." Everyone showed respect to a "middle aged man who was highly Tatoo'd particularly the back neck and Face," causing Cuming to consider him a chief (*ariki*). This observation establishes the Rapanui association of elaborate tattoo with age and rank.

In 1830, Lieut. J. Orlebar, R.N., while aboard HMS *Seringapatam* in Cook Bay, observed Rapanui men who were "much tattooed" and women "completely tattooed." In 1831, HMS *Blossom* called at Cook Bay. First Lieutenant George Peard and a landing party of about 12 men

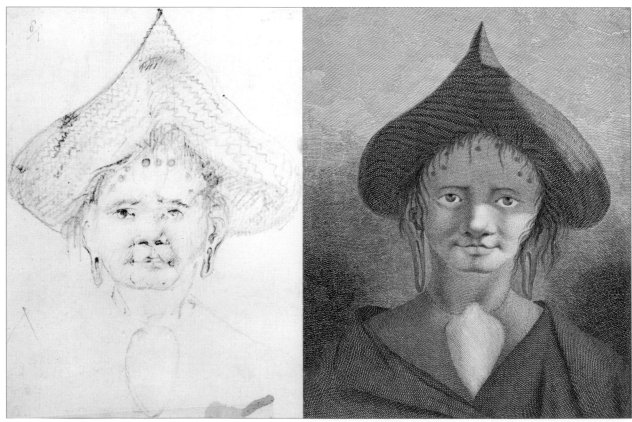

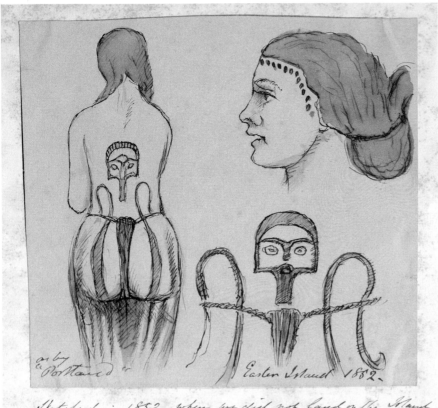

Sketched in 1852 when we did not land on the Island.
The people came off a few in canoes which were...

as by
a Portland

Easter Island 1852.

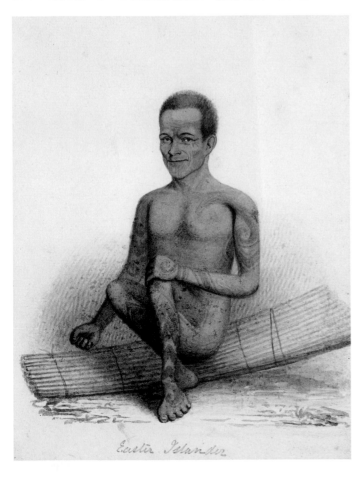

Easter Islander

"had a narrow escape at the hands of about a thousand hostile inhabitants who had expected presents" (Gough 1973, 34, 72–73). Peard reported that many of the males were "Tattooed & besmeared with Yellow Ochre & black paint over the face & lips & other parts of the body" (Beechey 1831). The younger females were all "without exception tattooed in front from the hips down to the knees of a dark blueish colour."

John Linton Palmer, the artist whom Tepano remembered and mentioned to Stolpe, is well known for his presence aboard HMS *Topaze* in 1868. One of Palmer's drawings attributed to the 1868 voyage shows three young Rapanui people ashore with a small outrigger canoe (*vaka*), a surf float (*pora*), and a scull oar (Figure 6). Paint or tattoo is indicated on the women's backs.

Before the 1868 voyage, however, Palmer was posted to HMS *Portland* as assistant surgeon from April 17, 1850, to February 17, 1851.[17] His name is also present on the ship's muster list in 1853 and 1854. According to Palmer's annotation of his archived sketch showing three views of a Rapanui woman's facial and body tattoos, it was "sketched in 1852 when we did not land on the Island" (Figure 12).

HMS *Portland* called a second time at Rapa Nui after departing Valparaíso on January 30, 1853. On February 24, the captain sent a cutter into Cook Bay to "communicate." It returned on February 25. Palmer's annotation states: "The people came off a few in canoes—which were extremely scarce—most by swimming. They brought also to the cutters which went ashore fowls and some Eggs, etc." Nothing further is noted and the *Portland* departed. An unknown artist aboard the *Portland* depicted a young Rapanui man with dramatic body art (Figures 13a and 13b).[18] He has a vertical line

FIG. 14
Rapa Nui coastline near Cook Bay. *Watercolor drawing, Louis Choris, undated.* Mark and Carolyn Blackburn Collection, Honolulu.

motif on his chin similar to one depicted on three bark-cloth figures collected at Rapa Nui a decade earlier. At the outside corner of his left eye appears a tiny, stylized bird resembling a frigate bird. This motif, along with his youth and his pose with a *pora*, establish him as a *hopu* (young man in service to the chief) who participated in the "birdman" (*taŋata manu*) rituals of Oroŋo. "Some twelve different authorities, of whom four had been birdmen, three had served as 'hopu,' and one had acted in both capacities" described these rituals to Katherine Routledge in 1914–15 (Routledge 1917, 339–44). The actual competitors "were men of importance" who "selected servants to represent them" in *taŋata manu* events. The "servants" were required to swim to the offshore islet of Motu Nui and await the arriving flocks of migratory seabirds, secure an egg of the sooty tern (*manutara*), and return to Oroŋo to present it to the man subsequently anointed *taŋata manu*:

[The hopu] made up his provisions into a "pora," or securely bound bundle of reeds, he then swam on the top of the packet, holding it with one arm and propelling himself with the remaining arm and both legs. An incantation, which was recited to us, was said by him before starting. (Routledge 1917, 339–44)

According to the records of the Royal Geographical Society, the drawing was donated there on August 20, 1940, "by one Mrs. Drogo-Montagu who, it is understood, had some connection with the J. Linton Palmer family" (Van Tilburg 1992, 36). We now know that Marion Kate Evelyn Doughty (Mrs. Drogo Montagu) was the daughter of Rear Admiral Frederick Proby Doughty (1834–92), commander in 1853 of HMS *Portland*, on which J. Linton Palmer served.[19] Thus we have established the young man's probable connection with the *taŋata manu* ritual, the Palmer family, and HMS *Portland*, and confirmed the date of 1853 for the drawing and the tattoo patterns. The artist remains unknown.

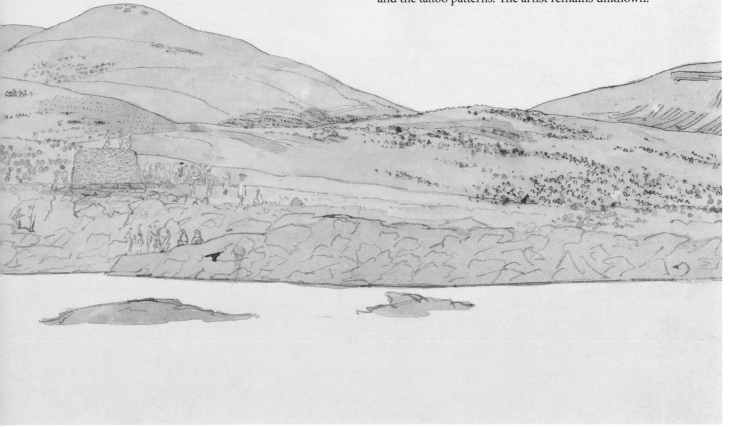

RAPANUI TATTOO AND COLONIALISM

The decade of the 1860s was a disaster for the Rapanui people as they suffered through slave raids (1862–63) and disease epidemics, including smallpox (1863–64) and tuberculosis (1867–70).[20] These catastrophes ravaged the community, caused the population to decline, and drastically reduced the ranks of all traditional experts, including practitioners of tattoo. Catholic missionaries began Christianizing the people in 1863, when Brother Eugène Eyraud (1820–68) arrived and started building his first residence on the heights above Apina Nui, roughly halfway along the coast between the modern village of Haŋa Roa and Mataveri. Tormented by a Miru man named Torometi (Kutano) and others, he soon fled the island. Missionization began in earnest in 1866, when Eyraud returned with Father Hippolyte Roussel, and Father Kaspar Zumbohm and Brother Théodule Escolan arrived from Chile and succeeded in outlawing tattooing; thus the Tattooed Man must have been adorned with most, or perhaps all, of his body and facial art by that date.

From 1864 to 1867, just before the arrival of HMS *Topaze*, Torometi dominated the Rapanui people clustered near the main mission in Haŋa Roa.[21] An equally obstreperous individual named Roma a Ure Moʻeŋa (from the Akahaŋa area) controlled the opposing group near Mataveri. He was fiercely jealous and protective of the old ways ("celoso de sus antiquas costumbres"; Englert 1996, 80). A watercolor sketch of Torometi by Dr. Palmer, surgeon aboard HMS *Topaze* in 1868, establishes that Torometi had no facial tattoo (Figure 15). Roma, of whom no illustration has yet been discovered, is said to have been "tattooed head to toe" (Knoche 1925, 222).

Torometi and Roma, after their Catholic conversion in 1868, reversed their positions of defending traditional beliefs. Roma became as fanatic about his new religion as he had been about the old ways (Englert 1996, 80–81). He would answer only to his Christian name (Tepano) and was aggressively protective of the missionaries and proud of his role as "gendarme," enforcer of rules and restrictions. Torometi now served the newly arrived Jean-Baptiste Onésime Dutrou-Bornier, generally characterized as manipulative, duplicitous, and despotic. Dutrou-Bornier was the French business partner of the wealthy colonial merchant and plantation owner John Brander, head of Maison Brander (La Maison Brandère), a Tahiti-based firm. Dutrou-Bornier had extensive dealings with the English colonial merchant Alexander Salmon and the Catholic Church through Florentin-Étienne Jaussen (1815–91), the apostolic vicar of Tahiti (Kaeppler 2003, 68; Prat 2015).

Realignments and relocations caused by Christianization and commerce forced important internal changes. First, these alterations blurred well-defined traditional geographical and estate boundaries, once distinguished by toponyms and demarked by *ahu* (raised rectangular stone ceremonial platforms). Second, social distinctions —and the accoutrements that visibly stated and enforced them—diminished. Unavoidable crises of personal and group identity resulted. Tattoo was one of the few remaining social distinctions visible to nineteenth-century visitors. Genealogical relationships to Hotu Matuʻa, the legendary founding ancestor of the Miru group and the paramount chief, traditionally determined Rapanui rank.

FIG. 15
Torometi. *Ink and wash drawing over pencil,*
John Linton Palmer, HMS Topaze, *Rapa Nui, 1868.*
Royal Geographical Society (with the Institute
of British Geographers), London.

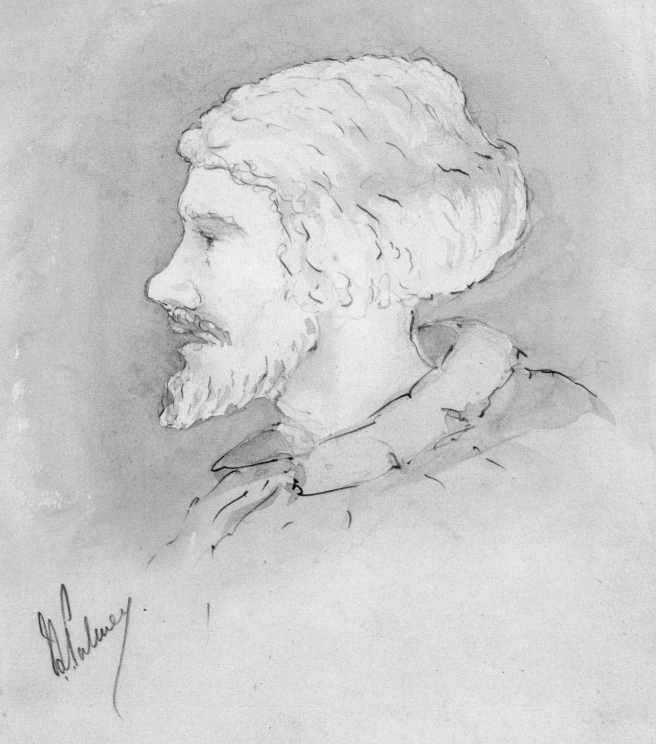

E. Palmer

Easter Island
Nov. 22. 1868

A well-known account of Rapanui islanders' origin and history illustrates the significance of tattoo in the telling of the ascendency of Hotu Matu'a and the dream vision of Haumaka, who had tattooed Hotu (Routledge 1919, 277–278).[22]

Later—first between March and October of 1871 and then between October and May of 1872—the missionaries abandoned Rapa Nui, and 409 members of the shattered community decamped with them.[23] John Brander's ships delivered 168 Rapanui migrants to the Catholic missionaries in Mangareva and 109, possibly including Roma and Torometi, to Tahiti. Some of these individuals had signed work contracts with Brander lasting three to five years.[24] Two years later, Brander's associate, Jean-Baptiste Dutrou-Bornier, whose presence had escalated indignity and violence to a level that made life on Rapa Nui intolerable, was murdered.

Lieutenant-Captain Wilhelm Geiseler of the German Imperial Navy stayed at Cook Bay aboard the *Hyäne* September 19–23, 1882. In only four days, with the assistance of Paymaster J. Weisser, he produced an account of the visit considered "reasonably reliable and accurate," although "one general problem in assessing reliability lies with the contributions" of Alexander Salmon Jr. (Ari'ipaea).[25]

Ari'ipaea, a well-connected member of the Tahitian royal family, was the colonial overseer for investments and interests shared with his cousin and business partner, John Brander Jr. (O'Reilly 1969, 26, Fig. 20). Ari'ipaea spoke English, Tahitian, and Rapanui; bought and sold property; hired and fired Rapanui people toiling in all lines of work; encouraged the making of handicrafts and the collection of antiquities; and brokered sales of these objects to visitors who called during his residence on Rapa Nui.

Geiseler says that "relatively speaking many men and women were found who were tattooed little or not at all":

We tried to find a uniform design, but we could not find any. Almost every person had a different design. The persons who were most tattooed were those persons who were identified as old chiefs, but even in these cases the designs differed. Uniformity was found only in the total tattooing of both the upper and lower lips. Certain individuals particularly women, have around their lips a thin blue line which extends upward to the nostrils and downward across the chin all the way down to the neck.... One very frequently finds also on women's foreheads a thick line of points; this line runs from the parting of the hair toward each ear in the shape of a semicircle. Then, this line breaks into branches of several thin lines on the ear itself and these thinner lines follow the contours of the ear auricle and proceed across the cheeks and end here in a few streaks. (Ayres and Ayres 1995, 71)[26]

Geiseler further notes that "men frequently had their necks tattooed with semi-circular lines which on the top ended on the cheek bones and on the bottom ended at the base of their necks" (Ayres and Ayres 1995, 71). This also describes the connected vertical crescent motifs (*umi umi*) seen on the Tattooed Man. Men were said to display their marital status by tattooing a vulva (*komari*) on their upper torsos (Ayres and Ayres 1995, 72).[27] Thus—in an apparent contradiction of his observation that the tattoos lacked uniform design—Geiseler describes the recurring traditional tattoo motifs of *retu*, *humu* or *puraki*, *kona*, *umi umi*, and *ua*. He does not emphasize the motif of vertical lines on the forehead.

In 1886, Paymaster William J. Thomson of USS *Mohican* conducted an archaeological field inventory and published a summary report (Thomson 1891). As with Geiseler just four years earlier, Thomson's cultural information depended on sources or materials provided by or accessed through Ari'ipaea, who once again acted as greeter, guide, salesman, and interpreter. Thomson noted that in the impoverished community of only 155 people, "all those advanced in life are ornamented on all parts of the body" (Thomson 1891, 466). Yet his published illustration of the tattoo patterns on a woman shows her as not "advanced in life," but quite young (Figure 16). His

FIG. 16
Tattoo patterns on a Rapanui woman.
Line drawing, William J. Thomson,
USS Mohican *(1889, 466, Figs. 4a*
and 4b). Smithsonian Institution.

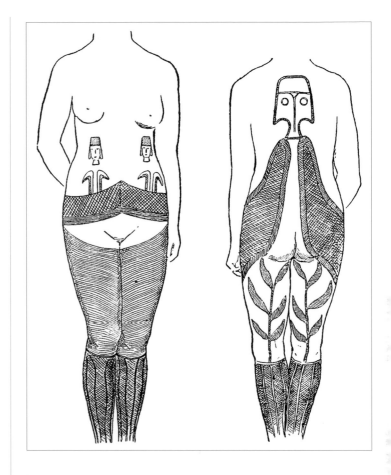

description of her facial tattoo accords well with Geiseler's account and with Knoche's depictions 25 years later:

The highest[28] ornamentation was as follows: A narrow band around the upper part of the forehead, at the edge of the roots of hair, with little circles extending down upon the forehead and joined to the band by a stem. From the coronet, a line extended around the outside edge of the ear, with a circle on the lobe. The lips were freely tattooed, after the manner of the Maoris, with lines curving around the chin and extending towards the cheek-bones; the entire neck and throat covered with oblique or wavy lines with occasional patches of solid coloring.

He also notes that the "oldest man among them is a chief called Mati; his actual age is not known, but he must be upwards of ninety, and his wife is nearly of the same age."[29] According to the information Juan Tepano gave Routledge in 1915, Mati was the only man Juan Tepano knew who was completely tattooed (Thomson 1891, 466–67). Thomson, echoing Geiseler's observation about the lack of uniformity in Rapanui tattoos, says that "unlike the Samoans and other islanders, where a standard pattern is adhered to," Rapanui tattoo was "only limited by the fancy and ability of the artists" (Thomson 1891, 466). Yet, except for the motifs sketched by Captain Charles Bishop, the enhanced line-and-dot motif on the forehead of the Tattooed Man, and the tiny stylized bird on the man drawn by the unknown artist aboard HMS *Portland*, the tattoos described or depicted between 1774 and 1886 are highly similar and recognizably Rapanui. Métraux states that related groups probably favored particular tattoo designs. He believes that "the persistence

of fundamental motifs, which were repeated on all individuals, both male and female, were faithfully preserved from one generation to the next" (Métraux 1940, 240).

We agree with Métraux and note that there is also evidence that the practice of tattoo continued clandestinely, at least until 1872, after the missionaries banned it. However, when one considers the depletion of the Rapanui population in the nineteenth century, the apparent loss of the more learned or higher-ranked individuals, the clustering of people from both sociopolitical regions in the area from Haŋa Roa to Mataveri, and Western ships' exclusive and continuous use of Cook Bay as an anchorage, we believe that nineteenth-century visitors illustrated certain memorable individuals more than once.[30]

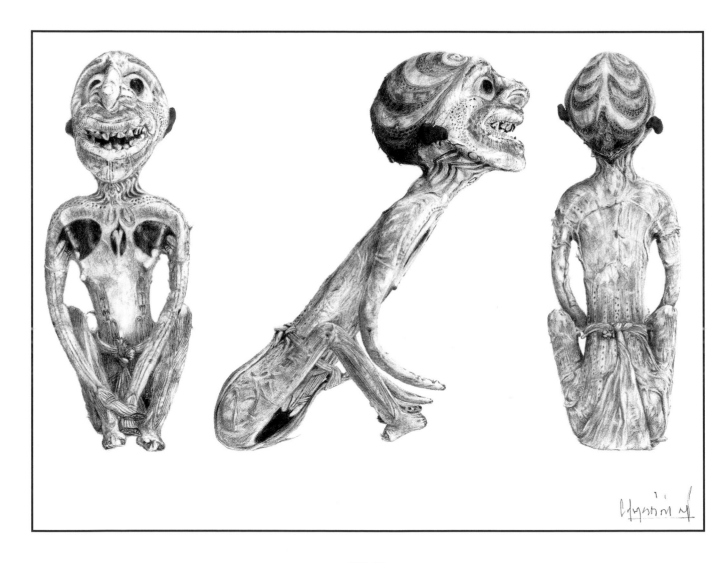

FIG. 17
Three drawings of barkcloth sculpture collected in 1839
or 1840, now in the Ulster Museum (BELUM.C1910.41).
Drawing by Cristián Arévalo Pakarati, 2008,
© EISP with permission of the Ulster Museum,
Belfast, Northern Ireland.

RAPANUI TATTOO DESIGNS AND MOTIFS

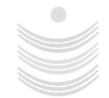

Rapanui tattoo (*ta* or *takona*) was always in the hands of experts—as is still true today. Tattoo artists were honored advisers to their patrons. Tattoo implements included a small bone mallet (*puauhu*) or wooden mallet (*miro puauhu*) and a bone needle (*uhi*; Figure 18).[31] The Rapanui motif repertoire for females included curved lines (*retu*) and dots (*humu* or *puraki*) on the foreheads and curvilinear motifs on both sides of the face (Routledge 1919, 219, Fig. 88). A Rapanui man known to Routledge was tattooed with the line-and-dot motif (Van Tilburg 2014, 391, Fig. 6). The *retu* motif in particular was usually one of the first tattoos received. Other motifs depicted objects of material culture, including adzes (*toki*) and dance paddles (*'ao*). Men favored elaborate linear throat, nose, and neck motifs (*ua*), as well as designs that outlined the clavicle, eyes, and ears. Dense patterns of vertical lines (*kona*) forming stylized vulva (*komari*) enhanced the legs of both females and males, and occasionally a vertical line motif appeared on the lower torso. Men also favored a chin motif of two or more commonly three vertical lines (*umi umi*).

Motifs similar to all of these embellish three barkcloth anthropomorphic sculptures in the round (Kaeppler 2003). In 1839 or 1840, Gordon Augustus Thomson—probably while in Hawai'i—collected one of these figures, now located in the Ulster Museum, Belfast, Northern Ireland (Figure 17; Kaeppler 2003, 28). The other two are in the Peabody Museum of Archaeology and Ethnology, Harvard University (Figure 19). They were transferred to the Peabody from the Boston Museum in 1899, along with other early materials including two barkcloth headpieces and 14 wood carvings from Rapa Nui (Kaeppler 2003). The Peabody figures appear to date to the 1840s.

FIG. 18

*Rapanui tattooing implements. Wooden mallet (*miro puauhu*) and needles (*uhi*), collected by Lieutenant-Captain Wilhelm Geiseler, 1882.* World Museum Vienna.

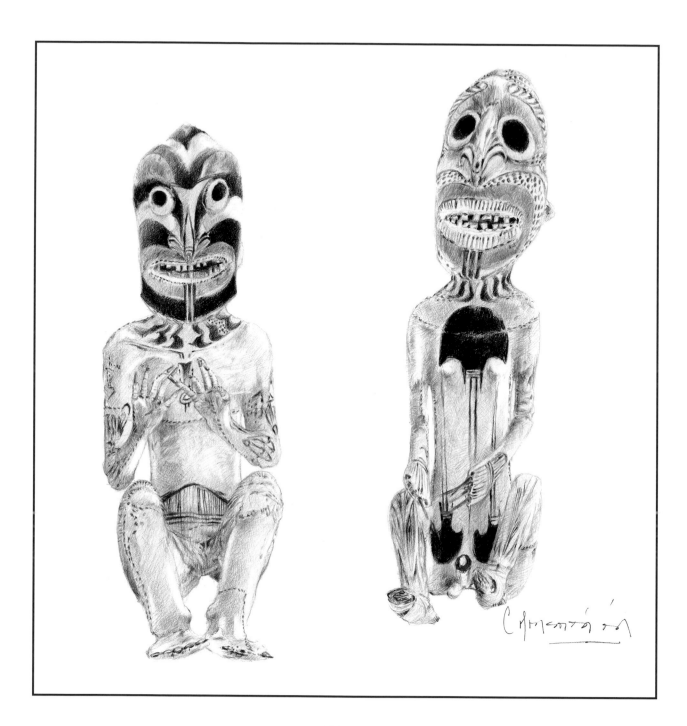

FIG. 19
Drawing of barkcloth sculpture (53543) and
male barkcloth sculpture (53542), both now in the
Peabody Museum of Archaeology and Ethnology.
Drawing by Cristián Arévalo Pakarati, 2000,
© EISP with permission of the Peabody Museum of
Archaeology and Ethnology, Harvard University.

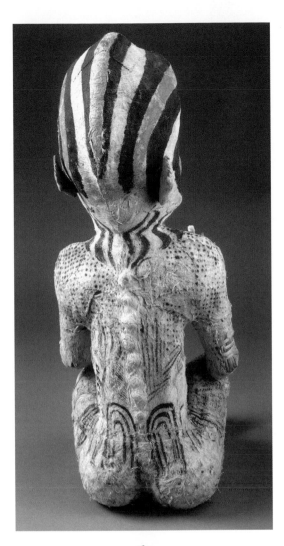

FIG. 20
Motif of parallel lines on back of barkcloth sculpture. Peabody Museum of Archaeology and Ethnology (PM 99-12-70/53543). Gift of the heirs of David Kimball, 1899. Photograph © President and Fellows of Harvard College.

Each of these three barkcloth figures is constructed of bundles of reeds tied with bands of natural fiber. The Belfast figure (Figure 17), unlike the Peabody figures (Figures 19 and 20), does not have wood clawlike fingers; it is also unique in that it is wearing a loincloth (*hami*), also of barkcloth, which denotes male gender. Pieces of historically acquired red cloth are attached to represent ears, and the eyes are of barkcloth. The barkcloth itself was probably originally much whiter but is now quite gray, relatively thin and worn, stitched in pieces of varying size and embellished with black, white, and variously faded red, orange, and brown natural pigments.

The designs on the necks and noses of the three barkcloth figures are important because they correspond to motifs on the Tattooed Man, as well as to other early documentation of tattoos. Vertical lines in association with rows of dots occur in both the Stolpe depictions of the Tattooed Man and in the barkcloth figures. In the Stolpe depictions, the addition of tiny lines on both sides of some of the vertical lines are unusual. They appear to represent arms and, if so, serve to anthropomorphize the dot-and-line motif. The barkcloth figures also include ornamentation of the chin with vertical lines similar to the vertical-line chin motif (*umi umi*) on the Rapanui man seen in the Cook Bay vicinity in 1852 (Figures 13a and 13b, p. 9). The Belfast figure (Figure 17) and Peabody figure 53542 (Figure 19) include slightly curved or wavy vertical throat lines that terminate in bird heads, eyes, and beaks, evoking the tiny, stylized bird on the Rapanui man in Figures 13a and 13b.

On the barkcloth figures, a crescentic, zoned area filled with multiple dots outlines the shoulders, and multiple parallel lines, connected in some places to form ovals representing the vulva (*komari*), decorate the limbs. Several parallel lines, running vertically along the spine and then slanted upward, embellish the back of Peabody figure 53543 (Figure 20). A similar design (Figure 21) appears on the Tattooed Man.

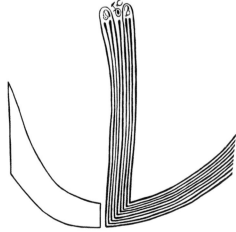

FIG. 21
Motif of parallel lines on back of Tattooed Man. Illustration, Stolpe (1899, 7, Fig. 7). Smithsonian Institution, photograph by Donald E. Hurlbert.

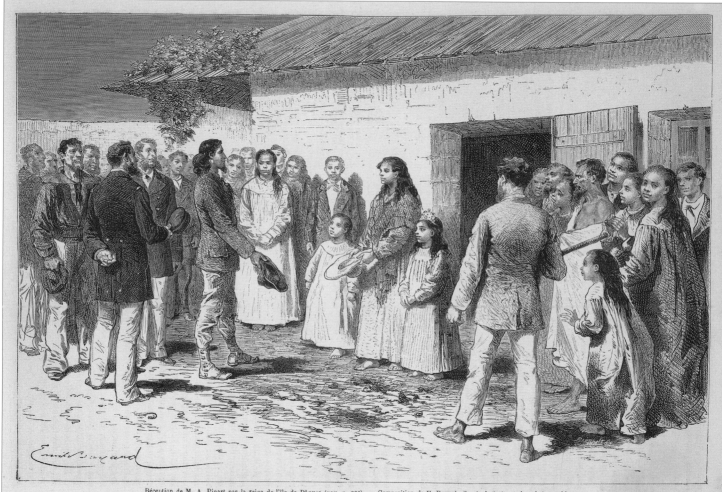

Réception de M. A. Pinart par la reine de l'île de Pâques (voy. p. 236). — Composition de E. Bayard, d'après le texte et des photographies.

FIG. 22A

Explorer Alphonse Pinart meeting with
Pua ʻAku Reŋa ko Reto, the so-called
Rapanui queen, at Mataveri.
Engraving, Émile Bayard, 1877
(in Pelletier 2012, 157).
Smithsonian Institution,
photograph by Donald E. Hurlbert.

DISCOVERING THE TATTOOED MAN

MATAVERI, APRIL 1877

We discovered the Tattooed Man hiding, as it were, in plain sight. In a well-known illustration by Émile Bayard (1837–91), the Tattooed Man is wrapped in a cloak and oddly conspicuous in the midst of a crowd surrounding the explorer Alphonse Louis Pinart (Figures 22a and 22b; Pinart 1878a, 238). The occasion was Pinart's meeting at Mataveri with the so-called Rapanui queen, Pua ʻAku Reŋa ko Reto (Koreto), and her children; she was the widow of Jean-Baptiste Onésime Dutrou-Bornier.[32]

In the Bayard illustration, the "handsome young explorer" Pinart is romanticized "as a cross between Stanley and d'Artagnan" (Parmenter 1966, 22).[33]

The meeting takes place in front of a building that looks more typical of South America than of Rapa Nui. The Tattooed Man is the only person not dressed in Western clothes and the only one with visible tattoos. He is shown in left profile, but otherwise he is unmistakably the same man Stolpe interviewed in Tahiti. We assume that the Tattooed Man was present at the removal of Hoa Hakananaiʻa from Oroŋo in November 1868. But did he then meet Alphonse Pinart at Mataveri in April 1877 before Stolpe interviewed him in Tahiti in May 1884? To track this odyssey, we began with the most dependable documentation and worked backward in time.

FIGURE 22B
Detail of Tattooed Man in the crowd at Mataveri during the meeting of Alphonse Pinart and Pua ʻAku Reŋa ko Reto.

KNUT HJALMAR STOLPE AND OSCAR ELKHOLM

TAHITI, MAY 1884

Knut Hjalmar Stolpe (1841–1905) was an archaeologist and anthropologist considered "Sweden's first real ethnographer" (Culin 1906, 155).[34] A graduate of the Uppsala Universität (University of Uppsala), he received his doctorate in 1872. He was a pioneer who applied the comparative typological method and artistry championed by General Augustus Henry Lane-Fox Pitt Rivers (1827–1900; Culin 1906, 152). According to Henry Balfour, Stolpe recognized early on that Polynesian aesthetic expression is primarily symbolic, and that decorative motifs "long retain their symbolic significance" despite conventionalization tending to obscure or obliterate recognizable design features (Balfour 1927, v). In short, Stolpe was a careful observer and one of the more experienced, well-informed ethnographers of his time.

Stolpe sailed aboard the Royal Swedish steam frigate HMS *Vanadis* on its voyage around the world in 1883–85. His mission—indeed, his scholarly passion—was to collect objects for a planned ethnographical museum in Stockholm. The *Vanadis* called at Pape'ete, Tahiti, the Marquesas Islands, and Hawai'i. In hopeful preparation for a visit to what he called the "peculiar island" of Rapa Nui, Stolpe conducted a search of the available literature, and he certainly consulted publications about Rapa Nui by Louis-Marie-Julien Viaud (known after 1872 by his pen name of Pierre Loti) and Alphonse Louis Pinart (Stolpe 1899, 1).

The *Vanadis* voyage collected about 7,500 objects, none of which is from Rapa Nui, where the ship did not call. Photographer Oscar Elkholm created about 700 glass photographic plates. Collected objects appeared in the "Vanadis exhibition" in Stockholm (1886) and Gothenberg (1887). These objects were incorporated into a museum founded in 1899 by the Royal Swedish Academy of Science (now the Naturhistoriska Riksmuseet or National Museum of Natural History). Here we find minor discrepancies between Stolpe's previously unpublished sketch (Figure 23) from the *Vanadis* diaries and Stolpe's 1899 published drawings of the Tattooed Man (Figures 7 and 21, pp. 5 and 19). The sketch of the back tattoo is not partially filled with parallel lines; nor does it have the four tiny motifs at the top. The sketch of the hand does not depict the thumb tattoo. The following translation from the published German summarizes the methods, in addition to photography (Figures 3 and 4, pp. 1 and 2), that Stolpe used to document the tattoos.

I sketched all tattooed parts (face, neck, back, stomach, hand and lower arm) carefully in their actual size. Since it turned out later on that the tattooing, even though weakly, but still rather distinctly did [show] in the photograph, the entering of the sketched pattern was an easy matter. The photographical transfer of the man's portrait onto the wood therefore may claim complete authenticity. (Stolpe 1883, 4–5)

FIG. 23
Original sketch of the Tattooed Man by Knut Hjalmar Stolpe.
"Ornamentik" file, Stolpe Archives,
Världskulturmuseerna, Sweden, photograph by Martin Schultz.

THE TATTOOED MAN AND MADAME HOARE

TAHITI, CIRCA 1870

Madame Sophia Hoare took the undated carte de visite photograph of the Tattooed Man (Frontispiece, p. ii) in her studio on Petite-Pologne Street in Papeʻete, Tahiti. This image does not identify the Tattooed Man by name, nor does it specify his age; based on appearance, he may be in his mid-30s. He appears to be wearing small disk ornaments, similar to the earplugs made of shark vertebrae that the Rapanui used (Kaeppler 2002, 40, Fig. 22). The tattoo patterns on his forehead stand out clearly and, although his beard somewhat obscures his neck patterns, Stolpe depicts them as a complex variant of the *ua* pattern.

Charles Burton "C. B." Hoare (1833–79) was originally from a working-class family in Manchester, England. He and his wife, Sophia Hoare (née Johnson), along with their three young daughters, arrived in Papeʻete from Auckland, New Zealand, in February 1868. A self-taught photographer, he had been a partner in a short-lived Auckland studio known as Hoare & Wooster. Sophia Hoare was destined to become a sought-after photographic artist catering to the Tahitian royal family.

In 1889, she received a major prize in Paris for her accomplishments, and thereafter she signed her work Madame (rather than Mrs.) Hoare.

In June 1868, C. B. Hoare departed on a three-month photo safari to neighboring islands. Once back in Tahiti, he announced that he had made "a complete collection of the views of Tahiti and the South Sea Islands" (O'Reilly 1969, 24). Madame Hoare shared this cultural interest and photographed groups of Rapanui people or individuals at the Haʻapape, Tahiti, mission compound residence of Florentin-Étienne "Tepano" Jaussen (1815–91).

In February 1870, C. B. Hoare announced that he (in actuality the entire family) was moving from College Street to a new studio on Petite-Pologne Street, also in Papeʻete. In January 1872, he may have sailed for San Francisco aboard the *Wanderer* without his family, but there is evidence that he remained in Tahiti at that time and departed later for California, where he apparently died in 1879. We assume that Madame Hoare's carte de visite photo of the Tattooed Man dates to no earlier than 1870.

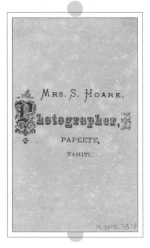

Reverse of carte de visite of the Tattooed Man by Madame Hoare (see Frontispiece, p. ii).

MADAME HOARE AND JULIEN VIAUD [PIERRE LOTI]

TAHITI, 1872

Louis-Marie-Julien Viaud (1850–1923; Pierre Loti is his nom de plume) visited Rapa Nui as a young naval cadet (age 22) aboard the French frigate *La Flore* January 3–7, 1872. The generally accepted estimated population at that time was just 191 persons. Julien Viaud made preliminary studies of several interesting men and women whom he met in the Cook Bay area, including males with facial tattoos similar to those of the Tattooed Man.

Through his older brother, Gustave Viaud (1826–65), Julien developed an interest in the newly emerging field of photography (O'Reilly 1969, 15, Fig. 4). Gustave arrived in Pape'ete, Tahiti, in June 1859 (some nine years before the arrival of C. B. and Madame Hoare). He remained there until June 1862, when poor health forced him to depart aboard the *Dorade* to Valparaíso, Chile, and then home to France. Gustave, as the first known photographer in Tahiti, produced calotypes featuring "vues immobiles" of Pape'ete and environs.[35] In Rochefort, France, between September 17 and December 2, 1862, Gustave and Julien Viaud viewed calotypes together. One of them was an 1860 image of Gustave's house in Pape'ete. We know this because Julien recognized the very same house in 1872 and sketched it as "la case abandonee [*sic*] de mon frère" (Quella-Villéger and Vercier 2010, 8–9).

Julien Viaud did not have a camera apparatus with him in the Pacific Islands. It was not until his later journeys to Africa and Asia that he mastered the art of photography and compiled an impressive portfolio of images.[36] He notes, however, that he "received as a souvenir from his good friends on Petite-Pologne Street some photographs" (O'Reilly 1969, 25).[37] The friends to whom he refers are Madame Hoare and her family.[38] We have determined that she photographed at least one of his drawings.

Based in part on this clear connection between Madame Hoare and Julien Viaud, we suggest that the Tattooed Man arrived in Tahiti between March and October 1871 aboard one of John Brander's ships, with a work contract indenturing him for three to five years. We further suggest that Madame Hoare photographed him in her studio on Petite-Pologne Street before Julien Viaud's arrival aboard *La Flore* in early 1872. As we will explore more fully below, we argue that Madame Hoare gave a copy of her photo of the Tattooed Man to Julien Viaud, and that he used it as the basis for at least one of his drawings of a Rapanui chief.

C. B. HOARE, CHARLES D. VOY, AND THOMAS CROFT

TAHITI, 1873

A widely reproduced group photo of Rapanui people with three priests was taken in front of Bishop Jaussen's mission residence. It features two young women holding infants, two men commonly assumed to be the women's husbands, and several boys. None of the Rapanui people appear to be tattooed, and nearly every male (including one of the priests) holds a carving that represents a class of objects.[39] Initials in the lower-right corner of the photo, possibly identifying the photographer, are indecipherable. McCall dates the photo to 1872 and credits it to Thomas Croft, an expatriate living in Tahiti (McCall 1994, 86). He states that Croft took numerous photos of Rapanui people, "his interest being their tattoos." Fischer dates the photo to August 28, 1873, and credits it to C. B. Hoare (Fischer 1997, 43). Orliac and Orliac credit it to Madame Hoare and say that it was "taken at the request of Mr. Croft" (Orliac and Orliac 2008, 92). The archive holding the original does not substantiate these attributions.[40]

Thomas Croft presented to the California Academy of Sciences two photographs of *kohau roŋoroŋo*, wooden boards having "a repertoire of carved symbols" (*Proceedings* 1874, 317, 323–24). In 1874, Croft followed up at the request of the academy with two letters of the same date

in which he describes a packet he is sending that contains "two good sets" of 52 numbered photographs of Rapanui objects (Croft 1875). The academy's president—at the time the renowned scientist George Davidson—received the photos.[41] Thomas Croft had other similar interactions in which he acted as a broker for collectors and institutions. In 1875, for example, he had dealings with Charles D. Voy, a California naturalist and collector who "accumulated private collections, of which he disposed" (Tee 2010, 2, 6; Churchill 1917). In 1878, Voy was in Oakland and, in a letter to Sir George Gray in Auckland, New Zealand, noted that he expected "to receive some photos of modern [roŋoroŋo] tablets." By that time, he had acquired at least one photo of a Rapanui carving (a lizard; *moko*).

Thomas Croft and his many interactions with Rapanui people and artifacts are important to this discussion because he mentions an unnamed Rapanui man said to have special knowledge of *roŋoroŋo*.[42] The man consulted with Croft for three Sundays, but they lost any rapport they might have had when Croft called attention to the lack of consistency in the man's interpretations of *roŋoroŋo* symbols. He then quit his association with Croft. It is not known whether this Rapanui man was tattooed.

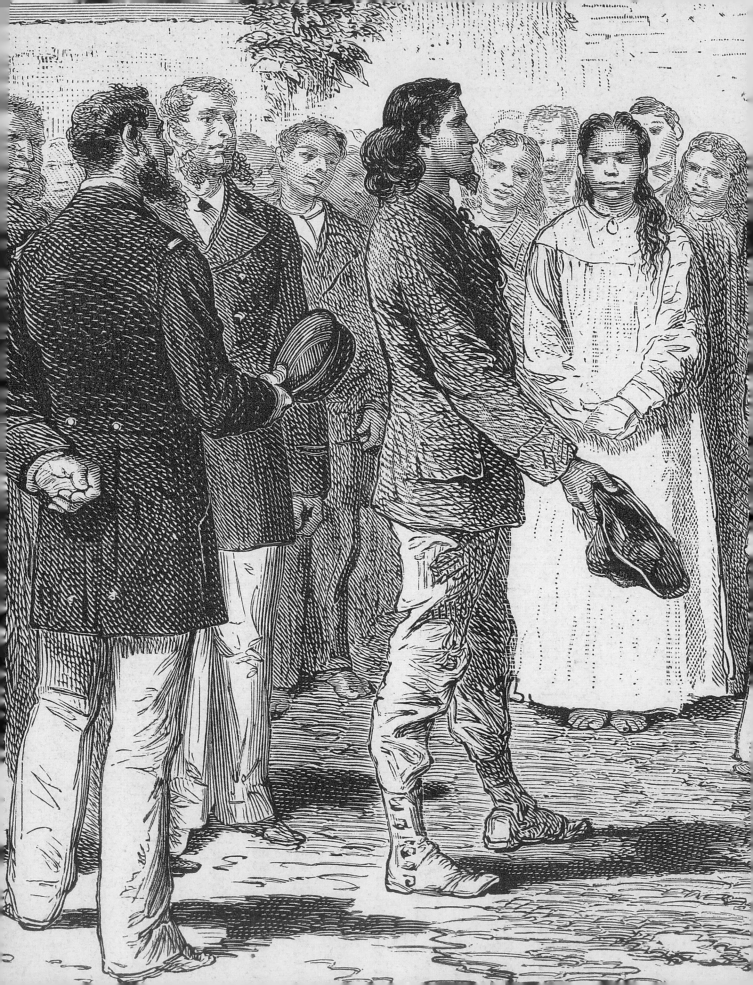

ALPHONSE LOUIS PINART

1877

We now jump forward five years to Alphonse Louis Pinart, who began his career as an ambitious, talented, and wealthy collector, linguist, ethnographer, and explorer and ended as a bankrupt figure, largely forgotten by members of the professions he had embraced (1852–1911; Pinart 1878a, 1878b).[43] Like Viaud, Pinart was young—just 25—when he first visited Rapa Nui in 1877 aboard the French man-of-war *Seignelay*. Unlike Viaud, however, he was not a romantic, but instead sought to be an objective observer.

Pinart published his first account of his visit to Rapa Nui as a chapter in *Le Tour du Monde*, a series of sophisticated, widely circulated illustrated travel volumes (Pinart 1878a). Parmenter claims that Pinart "must have been a talented sketcher, for almost all of the sixteen detailed illustrations by Alexandre de Bar" in that publication are based on Pinart's drawings (Parmenter 1966, 22).[44] On the contrary, none of the de Bar illustrations of *moai* can be considered accomplished, and none of them remotely resembles the ten diagrammatic sketches of *moai* in Pinart's original diaries.[45] In sharp contrast, the Émile Bayard illustration (Figure 22a, p. 20) in which the Tattooed Man appears is a professional, composite engraving meant to add drama to Pinart's historical meeting with Koreto at Mataveri. The photos Bayard used to produce the illustration probably included at least three men who accompanied Pinart ashore: M. Escande, Dr. Thoulon, and the photographer Lucien-Joseph Berryer.[46]

LUCIEN-JOSEPH BERRYER, RAPA NUI, APRIL 1877

Bayard was a Paris-based artist who worked in charcoal, paint, and watercolor and produced woodcuts, engravings, and lithographs for illustrated magazines (and at least one other illustration in another chapter of the same *Le Tour du Monde* volume mentioned above). He is not the photographer who was with Pinart on Rapa Nui.[47] That role fell to Lucien-Joseph Berryer (1850–1927). Pinart says that the entire village (population 110) was present at the Mataveri meeting. Nevertheless, he also says that Berryer "stayed in the village to photograph representative natives with the most characteristic features."[48]

Pinart comments on the clothing of the Rapanui, and notes that "only one old man, Tago, had a full-body and very complex tattoo" (Altman 2004, 2005). The question arises: Who was Tago? Could he have been the Tattooed Man? Possibly, but "old man" does not fit the probable age of the Tattooed Man in 1877. Nor, for that matter, does it fit the depiction of him in the Bayard illustration.

Another historical figure among the Rapanui is a man named Ko Tori, whose memorable facial tattoos Juan Tepano sketched for Katherine Routledge.[49] Tori, said to have been the island's last cannibal, departed

Rapa Nui for the island of Mangareva with Father Hippolyte Roussel, and the church there at Rikitea holds his family records.[50] He returned to Rapa Nui in 1888, along with Esteban Rutiraɲi, whom Father Englert claimed carried leprosy. Esteban, as in the Tattooed Man's name, is "Tepano" in Spanish. Tori died before 1915, and it is remotely possible that Tori is the "Tago" Pinart mentions in 1877. Tori's facial tattoos, as sketched by Juan Tepano, are not the same as those of the Tattooed Man.

Mati, the tattooed chief described by Thomson, was 81 years old in 1877 (Thomson 1891, 466). If he was still on the island after the exodus to Tahiti, and if Pinart mistakenly attributed the name "Tago" to Tori, then it is possible that Mati was the old, fully tattooed man Pinart says he saw. Did Pinart meet the Tattooed Man personally, either on the island or in Tahiti, or, alternatively, did he acquire a photo of him in Tahiti so that Bayard could use it, along with Julien Viaud's published illustrations, to insert his likeness into the engraving?

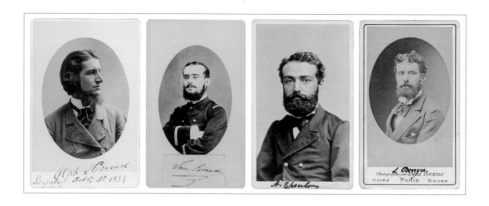

THOMAS CROFT, TAHITI, JUNE 1877

After departing Rapa Nui on April 6, 1877, the *Seignelay* steamed westward. In June 1877, Pinart was in Tahiti, where he made the acquaintance of Thomas Croft, the broker and collector who took an avid interest in Rapa Nui. Croft wrote a reply to an earlier inquiry by Alphonse Pinart. He told Pinart that he was in correspondence with the California Academy of Sciences and hoped to provide Pinart with a set of photographs similar to the one he had previously sent to the academy (and, as we have seen, either described or sold to Voy).[51] Croft notes that "Mr. C. B. Hoare, the photographer here, wishes me to state that he will preserve the negatives from which all these photographs have been taken."[52]

Croft sent the photographs to Pinart via the captain of the schooner *Nautilus*, then apparently at anchor at Pape'ete. The *Nautilus*, one of several ships owned by John Brander, made a monthly mail run between San Francisco and Pape'ete. Croft told Pinart that he was sending "photographs of several natives of Easter Island, men and women" who were "in employ of the missions."[53] It is logical to assume that if Croft had either his own or Madame Hoare's photo of the Tattooed Man—or, for that matter, of any other individual of interest for their tattoos or connection to roɲoroɲo—he would have included it in the packet he sent to Pinart.

CONSTANCE FREDERIKA GORDON CUMMING

AND ALPHONSE LOUIS PINART

1877

Constance Frederika Gordon Cumming (1837–1924) was a well-connected British woman and an accomplished artist who left a colorful record of her Pacific travels. She joined the *Seignelay* at Levuka, Fiji, on September 5, 1877, as a guest of one of the officers, M. L. de Gironde. Alphonse Pinart was a fellow passenger, and she frequently shared shore excursions with him. She collected cartes de visite of Pinart and her other shipmates, including three of the men who had accompanied Pinart ashore on Rapa Nui: M. Escande, Dr. Thoulon, and the photographer Lucien-Joseph Berryer (Figure 24; Kaeppler 2001, 261, Fig. 1).

Gordon Cumming describes Pinart as "pleasant and very ready to impart his information" (Gordon Cumming 1882, 5, 35). He showed her "many good photographs, done by himself, of objects of interest in many lands." He told her that the Rapanui were "very elaborately tattooed," and she regrets that the *Seignelay* had "no artist among her officers, so no one has any sketches which can give me a general idea of the isle, and though I have seen a few photographs of individual figures [statues?], I cannot from them obtain any impression of the whole effect" (Gordon Cumming 1882, 43).

On October 7, 1877, the *Seignelay* returned to Tahiti, finding the island in deep mourning for Queen Pomare, who had died on September 17, 1877. Gordon Cumming called on the recently widowed Mrs. John Brander (Tetua Salmon) almost immediately on landing in Tahiti, and the two women became fast friends. Indeed, they were distant relatives.[54] Gordon Cumming made the Brander country house (known locally as the Red House) her home away from home.[55] She also met Madame Hoare, who photographed some of her drawings (O'Reilly 1969, 24).[56] With little doubt, Madame Hoare took the three photographs of Gordon Cumming's drawings now held in the Peabody Museum of Archaeology and Anthropology at Harvard.

Pinart sailed almost immediately for San Francisco via Hawai'i aboard the *Nautilus*, and by 1878 he was back in France.[57] In record time (by March 1878), he made a presentation about Rapa Nui to the Société de Géographie, and in the same year he published his article in *Le Tour du Monde*. The article includes the composite engraving by Émile Bayard in which the Tattooed Man appears, as well as photographs of officers from the *Seignelay* and one or more photographs of the Tattooed Man taken by Madame Hoare in her Petite-Pologne Street studio. Pinart, like Julien Viaud before him, may have received those photos from Madame Hoare; alternatively, he may have acquired them through Thomas Croft.[58]

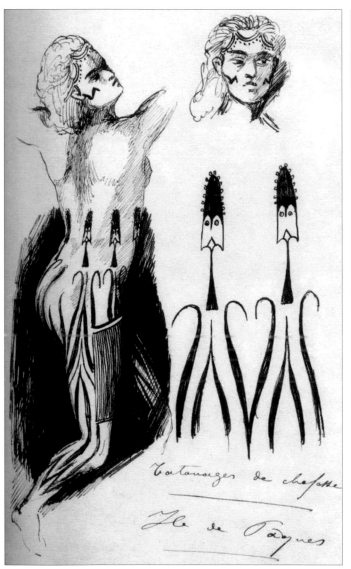 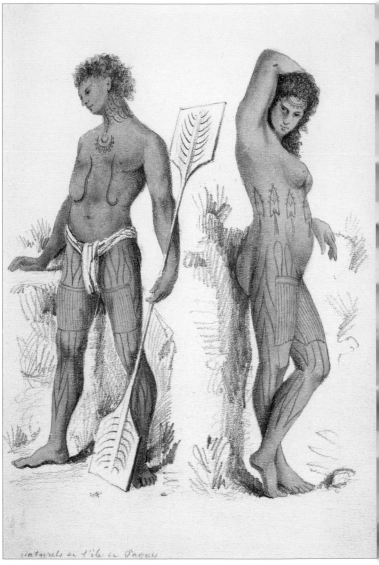

FIGS. 25A, 25B

Tatouages de chefesse—Île de Pâques.
Drawing, Julien Viaud (Pierre Loti), 1872.
Maison de Pierre Loti, Rochefort, France.

Naturels de l'île de Pâques.
Pencil drawing with color added, Julien Viaud (Pierre Loti), 1872.
Mark and Carolyn Blackburn Collection, Honolulu.

DRAWINGS BY JULIEN VIAUD [PIERRE LOTI]

We now return to 1872 and the young Julien Viaud (Pierre Loti), the French naval cadet aboard *La Flore*. Between arrival at Rapa Nui on January 3 and departure on January 8, Viaud went ashore in the Haŋa Piko vicinity multiple times. He met, vividly described, and sketched Rapanui people living along the shore of Cook Bay between Mataveri and Haŋa Roa. He spent most of his time with one group, living in the vicinity of Haŋa Piko near Mataveri. While ashore there, Viaud observed a more traditionally attired, tattooed group of Rapanui people who kept themselves apart and refrained from contact with him. He could be describing the group that Roma, the new convert to Christianity, had abandoned:

Others are watching us in a state of pensive immobility. On the rocks that surrounded us like an amphitheater, facing the sea, another segment of the population, more fearful or less friendly, is arrayed; these are people whom we have not met. There are men with many tattoos, kneeling with their hands clasped on their knees; there are women sitting as still as statues, with pieces of white cloth on their shoulders and, around their hair, which is gathered up in the style of the ancients, they have crowns of reeds. Not a movement, not a sign, not a single noise; all they do is watch us, at a distance, from above. (Altman 2004, 2005)

An extended family, headed by a tattooed male elder whom he referred to as the *vieux chef* (old chief), took Viaud in. The family occupied a traditional elliptical house (*hare pa'eŋa* or *hare vaka*) at Haŋa Piko.[59] Reed mats covered the interior floor of the house and, because the family was creative and prolific, carved wood figures and ceremonial paddles, feather headdresses, spears tipped with obsidian, and other objects hung on the walls. These objects were available for trade or barter with visitors, and Viaud acquired several pieces (Loti 1988a, 114, Fig. 29). The "old chief" used an adjacent cave, and a woman whom Viaud called the "chefess" cultivated a nearby field of sweet potatoes (*kumara*) with her daughter.

There is no doubt that Julien Viaud replicated his drawings of the statues and people of Rapa Nui many times over. They were highly popular with the crew of *La Flore*. In January 1872, Viaud wrote to his sister Marie Viaud from Nuku Hiva, Marquesas Islands, to say that he was tired of copying his drawings for officers, including "cinq éditions d'une même image"[60] (Loti 1998d, 117). He wrote to Marie again from San Francisco in May 1872, telling her that he was sending "une caisse contenant des dessins des l'île de Pâques" (Loti 1998d, 119).[61] He asked her to offer them to various publications, which she did, quite successfully. Various magazines used Viaud's drawings to create graphic illustrations for widely circulated popular publications, including *L'Illustration* and *Harper's Weekly*.

All of Julien Viaud's sketches, drawings, and engravings of tattooed Rapanui people are very important to scholarship. However, they have been widely published without a critical evaluation as to their dates and chronological and stylistic linkages (as have similar visual documents elsewhere; Smith 1950, 1985, 1992). This has caused significant confusion as to the number of Rapanui people who were tattooed, the types of motifs they preferred, and the identities of the individuals depicted.

For example, a drawing Viaud first published as *Portrait d'un chef de l'Île de Pâques* is a preliminary study (Figure 26b; Loti 1988a, 74, Fig. 20). A second, reworked drawing emphasizing the tattoos on the same man is titled *Tatouages d'un chef de l'Île de Pâques* (Figure 26c; Loti 1988c, 31, Fig. 8). Loti used both versions to produce a widely published engraving also titled *Tatouages d'un chef de l'Île de Pâques* (Figure 26d; Viaud 1872, 133).[62] The tattoo patterns depicted in the engraving are more distinctly drawn but, significantly, they are not precisely the same as those in the sketches. For example, the vertical lines on the lips are not shown in the "portrait d'un chef" but are present in the "tatouages d'un chef." When viewed as a composite illustration with Madame Hoare's photo of the Tattooed Man (Figure 26a), the similarities in all four depictions are evident.

FIGS. 26A–D

Composite illustration of the Tattooed Man:

A. *Carte de visite, Madame Sophia Hoare, Tahiti, 1870s (detail of Frontispiece, p. ii);*

B. *Pencil drawing, Julien Viaud (Pierre Loti), 1872;*

C. *Detail of drawing with watercolor wash, Julien Viaud (Pierre Loti), 1872 (Figure 31, p. 38);*

D. *Published reproduction of Figure 26c (Viaud 1873, 67).*

FIGURES B–C: Maison de Pierre Loti, Rochefort.

Julien Viaud also produced a preliminary study of an older woman who was the wife of a chief (Loti 1988c, 33, Fig. 9). Titled *Tatouages de chefesse—Île de Pâques*, it details her tattoos. It is the basis for a differently posed but more refined illustration titled *Naturels de l'île de Pâques* (Figures 25a and 25b; Viaud 1872, 133). In the preliminary study, she is the mature wife of a chief. In the finished illustration, she is the younger and more attractive daughter of a chief. She is shown with a tattooed young man whom Viaud calls "chief."

Viaud's published *Journal*, edited from the original written aboard *La Flore*, names three young people: Honga (Hoŋa), a "fine little savage"; Petero; and Marie. Petero and Marie were tattooed. It is possible that Petero was the model for the young "chief" and that the "fille de chef" is a composite of the body, face, and tattoos of the young Marie and her mother, the more mature "chefesse." Marie and her mother would be the two women of the "old chief's" household whom Viaud saw tending a field of sweet potatoes inland from Haŋa Piko.

Viaud annotated a preliminary study of an impressive young woman "Rapa-nui" (Figure 27a; Loti 1988a, 77, Fig. 21). Her facial tattoos include vertical lines on the mouth, an adze-like motif on her left cheek, and a related, complex, but not fully realized motif on her jaw that includes a horizontal crescent and three vertical lines. In the finished illustration, Viaud named her "Uaritaï" and simplified her tattoos (Figure 27b; Loti 1988a, 58, Fig. 18). He eliminated the cheek motif, emphasized the adze-like motif and the *retu* and *humu* or *puraki* motifs, and eliminated the lines on the mouth.

A B C D

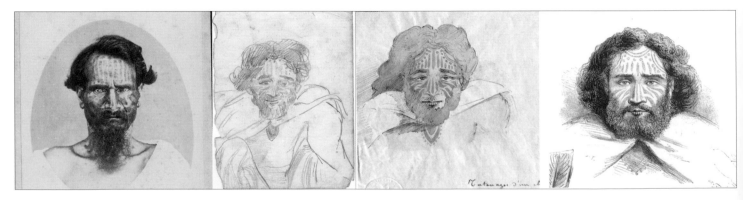

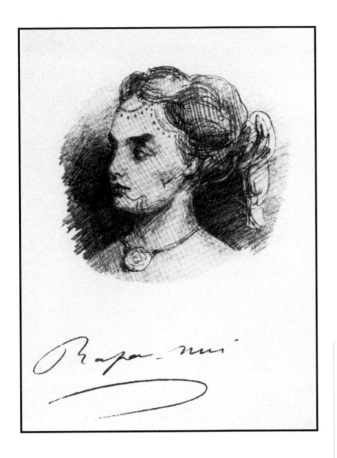

FIGS. 27A, 27B

Young Rapanui woman with facial tattoos.
Reproduction of a drawing, Julien Viaud (Pierre Loti), 1872.
Maison de Pierre Loti, Rochefort, France.

Uaritaï. *Reproduction of a drawing,*
Julien Viaud (Pierre Loti), 1872.
Maison de Pierre Loti, Rochefort, France.

We conclude that Julien Viaud reworked and altered his drawings of Rapanui women to create female faces and forms that were more conventionally attractive to Europeans, and that he did not consistently depict their tattoo patterns with accuracy.

The "old chief" is a striking personality in Viaud's written descriptions: a craftsman and tattoo expert, a respected elder, and a man with a wily presence born of a warm, lively sense of humor and an eccentric yet calculating outlook. His age is not known, and to Viaud he may have appeared older than he actually was. He wore other symbols of status in addition to his tattoos, including an impressive feather headdress (as did the "chief").

From the moment Julien Viaud set foot on the island, the "old chief" cleverly and assertively claimed him as a trading partner. He also clandestinely offered to tattoo

Viaud, or to trade "black dust in a pouch of dead leaves, which he refers to as 'tattoo,'" for a pair of trousers (Altman 2004, 2005). Viaud traded Admiral de Lapelin's greatcoat for a small stone figure (*moai ma'ea*) owned by the "old chief." It was heavy enough that two sailors were needed to carry it to a waiting boat. Viaud, in a reflective look back from deck as *La Flore* departed, writes:

Only the old chief, who came down to the shore to see me off, is returning slowly to his hut. And, seeing him looking so ridiculous and pathetic in his admiral's great-coat with his long naked tattooed legs sticking out beneath it, I feel that I might not have shown him sufficient respect, when I made our bargain, and that I might have treated him with much less than the dignity that he deserved. (Altman 2004, 2005)

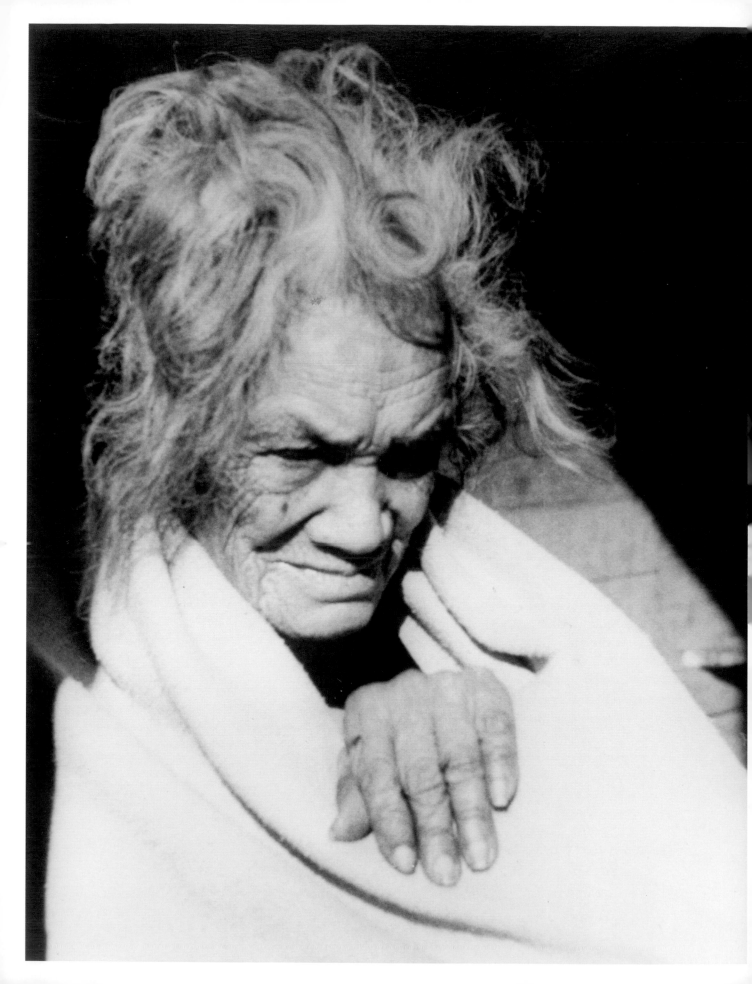

IDENTIFYING JULIEN VIAUD'S [PIERRE LOTI'S] RAPANUI SUBJECTS

Our attempt to identify Julien Viaud's (Pierre Loti's) Rapanui subjects is problematic for the simple reason that his drawings are impressionistic and idealized, and he does not always depict the tattoo patterns accurately. He did not intend them to be scientific records. As such, they are not as dependable as Madame Hoare's photograph or Hjalmar Stolpe's careful documentation. Nonetheless, the fact remains that the population of Rapa Nui in 1872 was extremely small, which increases the odds of identifying Viaud's subjects. Also, with the arrival of the missionaries in 1864–68, the survivors, no matter which sociopolitical district they originally came from, relocated to the area around Mataveri and Haŋa Piko to Haŋa Roa, and all of the ships called there (map, p. 44). Perhaps most important, once visitors named, described, or depicted an individual Rapanui person, subsequent visitors always singled out those individuals again. This is essentially true throughout the Pacific Islands, and the fact that every investigator who followed Katherine Routledge employed the same consultants, including—and especially—Juan Tepano, substantiates the connection of this pattern to Rapa Nui.

Based on the overall genealogical context, the most likely candidate[63] for the identity of the "old chief" is Atamu 'Ao Tahi. His son was Atamu Tekena (Hotus et al. 1988, 229).[64] In 1883, Bishop Jaussen appointed Atamu Tekena "king" of the Rapanui community. The slowly growing population at the time was about 167 persons (up from the low of 110 in 1876). Atamu Tekena was still king in 1886, and in 1888 he presided over Chile's annexation of Rapa Nui. Atamu Tekena may not have been tattooed (G. McCall, personal communication, 2014). If that could be proven, it would make him an unacceptable candidate for Julien Viaud's "chief."[65]

Uka a Hei a' Arero (known as Eva or Reina Eva; Figure 28) of the Ure O Hei was the tattooed wife of Atamu Tekena.[66] Eva's birthdate is not known for certain, but Métraux says that she was a "younger" contemporary of Juan Tepano's mother, Victoria Veriamo a Huki a Parapara of the Hiti 'Uira (Figures 29 and 30; Métraux 1940, 3, 239). Both women were tattooed in their youth, although their facial patterns were not exactly the same (Métraux 1940, 238–39). Veriamo told Routledge that she had lived at 'Anakena with the second of her three husbands, a man named Vaka Ariki, and that an artist named Tomenika had tattooed her there. This may be Tomanika (Dominic) Vaka Tuku Oŋe, whom the missionaries appointed catechist and who was the founder of the Pate family line.

Métraux says that Eva was "probably decorated when the last experts were dying" and describes her tattoos:

Ana Eva Hei has two parallel stripes crossing her forehead from one ear to the other and the inner edge of the ear tattooed.... The design on her lower jaw is composed of a triangular figure which meets an oval design, together forming an open angle. Her hands are covered with thin blue lines reminiscent of mittens. (Métraux 1940, 238 39)

FIG. 28
Uka a Hei a' Arero (Eva or Reina Eva),
tattooed Rapanui elder.
Photograph, Robert Gerstmann, undated.
Bishop Museum, Honolulu.

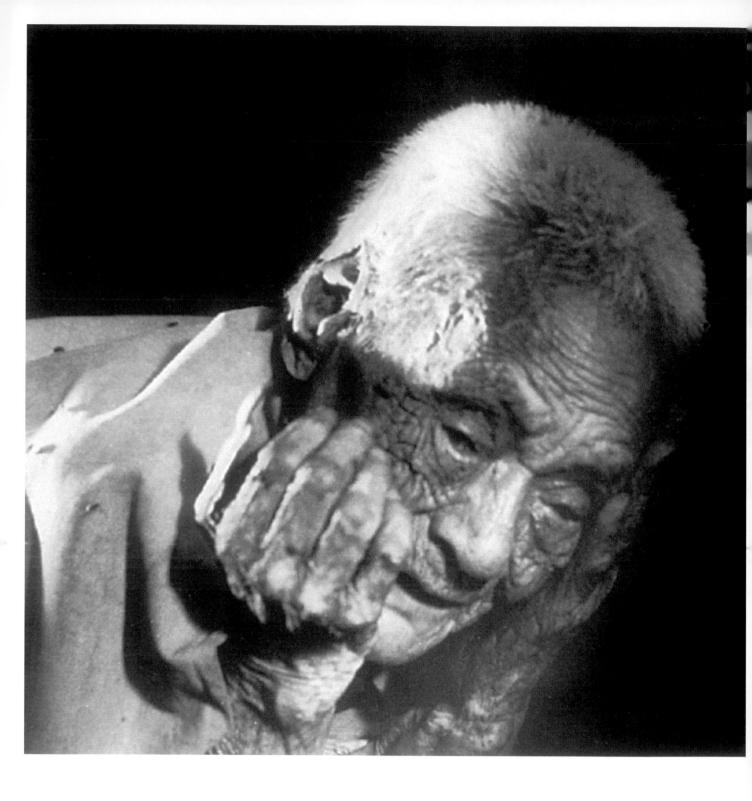

FIG. 29
Victoria Veriamo a Huki a Parapara,
tattooed mother of Juan Tepano.
Photograph, Alfred Métraux, undated.
Bishop Museum, Honolulu.

Lavachery's sketch of Eva validates Métraux's description, and both match Thomson's description of female facial tattoo in general (Lavachery 1939; Métraux 1940, 241, Fig. 32b). Each in turn almost precisely matches Knoche's illustration of a tattooed woman in her 60s whom he met in 1911 (Knoche 1925).[67] The tattoos are all similar to those depicted by Julien Viaud in his preliminary study of the older woman he called "chefesse" (Figure 25a, p. 30; Loti 1988a, 33, Fig. 9).

Assuming an estimated birth year of 1835 for Veriamo, she would have been about 37 years old when Viaud arrived in 1872. Eva, whom Métraux says was "younger" than "old Veriamo," died ca. 1949 at nearly 100 years old (Métraux 1940, 3, 238–39). Assuming that is roughly correct, Eva was born around 1849. Thus she was about 62 years old in 1911, as Knoche says, and about 23 years old in 1872. Her youth at that time, her status and relationship to Atamu Tekena, and the fact that her facial tattoos (with the exception of the variant motifs noted above) were almost identical to those of Julien Viaud's Uaritaï (Figure 27b, p. 33) all suggest that, as we believe, Uka a Hei (Eva) is Uaritaï. Veriamo, in contrast, is closer in age to Viaud's more mature "chefesse."

In strong support of this identification is the fact that Eva was an exceptionally memorable woman. The late, venerable Luis Avaka Paoa (Papa Kiko, 1926–2008) remembered his first encounter as a child with Eva, who was a friend of his grandmother and occasionally took care of him. He found Eva interesting but frightening. He remembers her tattooed face and recalls that she danced and sang a traditional song of warfare and cannibalism in a fine, strong voice.

Knoche says that the unnamed older woman of the two he depicts is 90 years old, suggesting that she was born about 1821. Her right hand is tattooed in a pattern "reminiscent of mittens." Like Eva (and Uaritaï), she has a tattoo on her cheek in a geometric, adze-like motif and parallel stripes crossing her forehead, below which are dots. She also has "elaborate designs on her body" (Métraux 1940, 240). These match those sketched on shipboard by J. Linton Palmer in 1853 and depicted by Julien Viaud on the "chefesse." However, Palmer's sketch is of a young woman; the 90-year-old woman whom Knoche met would have been about 32 years old in 1853.[68] Bearing in mind, however, the propensity of early visitors to idealize and conventionalize their depictions of women, it's possible that Palmer's sketch does not depict her age accurately.

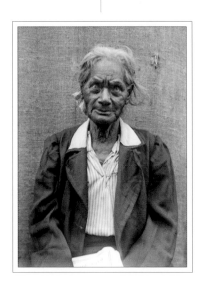

FIG. 30
Veriamo, ca. 1914.
Royal Geographical Society (with the Institute of British Geographers).

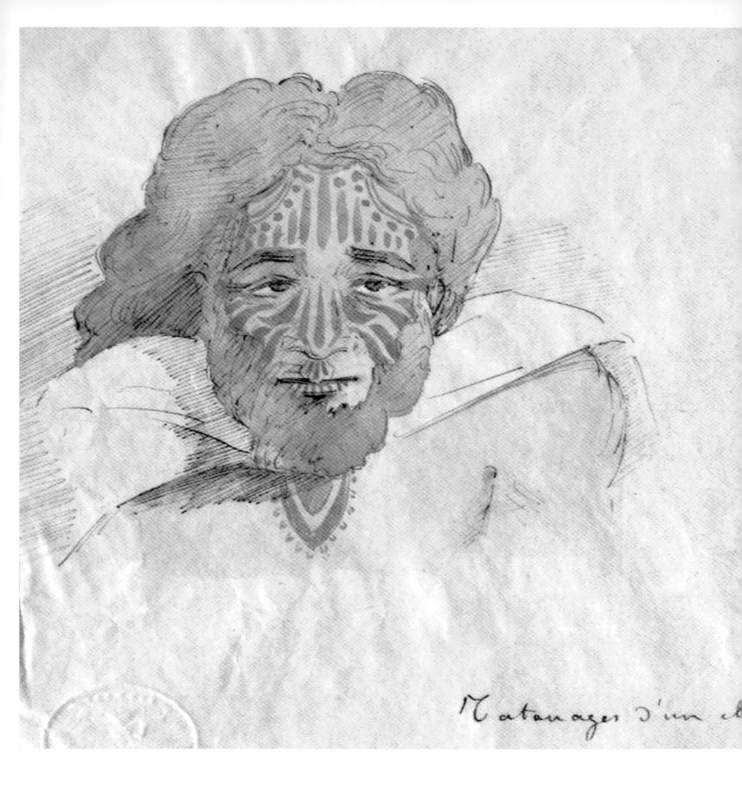

Tatouages d'un ch

FIG. 31
Detail of Tatouages d'un chef de l'Île de Pâques.
Drawing with watercolor wash,
Julien Viaud (Pierre Loti), 1872.
Maison de Pierre Loti, Rochefort.

IDENTIFYING THE TATTOOED MAN

VIABLE CANDIDATES

If we give the same credence to a roughly incised tattoo that we accord to the images in photographs and drawings, that tattoo offers clear evidence that the Tattooed Man was at Rapa Nui in 1868. We believe that he traveled to Tahiti during the depopulation of the island encouraged by the missionaries and facilitated by John Brander (with Dutrou-Bornier). There were at least three ships on which he may have sailed in 1871. Like others of his compatriots, he had probably agreed to work on Brander's plantations under the terms of a contract lasting three to five years (Muñoz 2015, 7).[69] Brander departed with 28 Rapanui aboard the *Marama* on March 9, 1871. Nine days later, another small group (37 Rapanui) sailed aboard the *Mahina*. If the Tattooed Man departed three months later (June 6, 1871) with 276 Rapanui immigrants aboard the *Sir John Burgoyne*, there is a chance he disembarked for a time with the missionaries at Mangareva. The other, less likely travel opportunity he had before Julien Viaud (Pierre Loti) arrived at Rapa Nui was on October 6, 1871. The Tattooed Man may have been one of two Rapanui who departed on that date, again aboard the *Sir John Burgoyne*. In any case, the Tattooed Man was not at Rapa Nui when Julien Viaud arrived aboard *La Flore*.

The Rapanui immigrants to Tahiti were largely young males in relatively good health. Those who did not fall ill and were able to discharge their obligation to Brander were free to return to Rapa Nui if they wished; many stayed and continued to work with the missionaries or elsewhere in Tahiti. The Tattooed Man made his way to the docks and warehouses of Pape'ete.

We reviewed the available evidence for nine Rapanui men who were possible candidates for the identity of the Tattooed Man (see note 63), and two possibilities emerged.

The first is Tepano Hakarevareva. Bishop Jaussen lists him as having bought land (plot 25) in Pamatai, Tahiti, in 1886.[70] Recalling his connections with the Miru site of 'Anakena, he named his land 'Anakena Papamarama. Hakarevareva married a Tahitian woman named Marie Rima One, and they had a daughter (Piramarama Mure, 1882–98; Muñoz 2015, 11, Table 4). She died young, and Maria Tepano (Marie Rima One, Hakarevareva's widow) sold his land in 1905. We do not know where Tepano Hakarevareva died and was buried, nor do we know for certain that he was tattooed.

The second candidate, whom we believe is in fact the Tattooed Man, is Vaka Ariki.[71] He was the second husband of the tattooed woman Veriamo (Figures 29 and 30, pp. 36 and 37) and was a Miru. Veriamo went to live with Vaka Ariki at 'Anakena:

[His] house already contained a wife and family, also four brothers, but they all got on quite happily together. She had five children by this man [Vaka Ariki] who, like their father, were all white [of pale complexion]; four of them, however, died in infancy. This was the result of the parents having most unfortunately fallen foul of an old man, whose cloak had been taken without his consent and who had accordingly prophesied disaster. The remaining child, a daughter, was living and unmarried when we were on the island. (Routledge 1919, 228)

In favor of Vaka Ariki is the memorial stone in the Rapanui leper cemetery that bears the name "Vacariki, Veriamo Catalina" and the death date of 1923, age 46. If the stone's inscription is correct, Catalina's birth year was about 1877, and she was Veriamo's "remaining child" by Vaka Ariki. Juan Tepano, Veriamo's son by Rano, her

third husband, had a sister or half sister living in the leper colony in 1914. If their birth years are correct, Catalina would have been about one to three years older than Juan Tepano. Catalina's birth date suggests that Vaka Ariki returned to Rapa Nui in 1876, after completing his work contract with John Brander.

VAKA ARIKI: A PROBABLE BIOGRAPHY

Assuming that the Tattooed Man was indeed Vaka Ariki of 'Anakena, he was a high-ranking Miru. The extent and quality of his tattoos alone support his 'Anakena connection, his Miru status, and his family's ample resources. As we have seen, the anthropomorphized vertical line motif on his forehead is unique. The tattoo he incised on his right forearm, depicting the removal of Hoa Hakananai'a from Oroŋo, reveals a man of spontaneous passion and, perhaps, substantial anger.[72] This tattoo makes sense in terms of the strong link the Miru have with Oroŋo and specifically with the statue Hoa Hakananai'a, removed from there in 1868. Moreover, Vaka Ariki could well have been a *taŋata manu*, and the young man drawn by an unknown artist (Figure 13a, p. 9) could have been a *hopu*.

We suggest a birth year for Vaka Ariki of about 1835. Like others in the Rapanui community of the time, he was tattooed before the arrival of the missionaries in 1864. He left 'Anakena for the Cook Bay area sometime between that date and 1868, when he was baptized and took the Christian name Tepano (as did many other converts). Vaka Ariki then departed Rapa Nui for Tahiti aboard one of John Brander's ships between March 9 and June 6, 1871. Like other Rapanui men and women, he agreed to a three- to five-year work contract with Brander's firm. He may have worked for a time on one of Brander's plantations; he ended up, however, on the Pape'ete docks. Brander's vessels went back and forth regularly to San Francisco, the Marquesas Islands, and elsewhere, including Rapa Nui. Thus, Vaka Ariki had multiple intra-island travel opportunities. His Rapanui name, which roughly translates as "canoe" (*vaka*) and "chief" (*ariki*), substantiates his apparent interest in or expertise with ships and supports the likelihood of a connection through his Miru heritage with chiefly canoes.

The arrival of so many immigrants from Rapa Nui did not go unnoticed in Pape'ete, and Vaka Ariki was noteworthy for his tattoos. He caught the eye of Madame Hoare or her husband, both of whom were busily photographing exotic locales and colorful islanders. Vaka Ariki sat for Madame Hoare at her studio on Petite-Pologne Street in Pape'ete sometime after July 1871 and before January 1872. She took one or more carte de visite exposures of him. Most carte de visite cameras of the time "could take four images simultaneously by one exposure and then move the plate and take four more" (Darrah 1981, 12).

After Julien Viaud departed from Rapa Nui, he visited other islands, arriving in Tahiti on January 29, 1872. He received a copy of the Vaka Ariki carte de visite photo from Madame Hoare or C. B. Hoare, "his good friends on Petite-Pologne Street." Viaud used it for his illustration called *Portrait d'un chef*. This was followed by *Tatouages d'un chef*, the basis for the engraving in his rapidly published *L'Illustration* article (August 1872).

Sometime between 1874 and 1876, Vaka Ariki completed his contract with Brander and returned to Rapa Nui. It is possible that Alphonse Pinart, who was certainly familiar with Julien Viaud's (Pierre Loti's) publications and illustrations, saw Vaka Ariki at Mataveri but did not sketch him, or that Lucien-Joseph Berryer saw him in Haŋa Roa (it's not known whether Berryer photographed him). Like Julien Viaud before him, and perhaps inspired by Viaud's illustrations and Constance Gordon

Cumming's unanswered requests to see photos or drawings of Rapanui people and places, Pinart sought out photos from Thomas Croft in Tahiti. Pinart bought or received from Madame Hoare or Thomas Croft a copy of her carte de visite of Vaka Ariki. He then rushed it to Émile Bayard, who then rendered Vaka Ariki into the engraving of Pinart meeting Koreto at Mataveri.

In about 1877, Vaka Ariki's daughter Catalina Veriamo Vacariki was born on Rapa Nui. At an unknown date (before 1884), he departed from Rapa Nui to return to Tahiti. When Stolpe says that he was "lucky" to meet the "beautifully tattooed" Rapanui man known as "Tepano" in Tahiti in 1884, he is being modest about his investigative skills (Stolpe 1899). Stolpe's research before the voyage certainly uncovered the Julien Viaud illustrations, and he must have noted (as we did) the appearance of the Tattooed Man in Bayard's engraving (Figure 32a). Inquiries in Tahiti led Stolpe to the Papeʻete docks. In fact, it appears that Carl Olof Sörling's profile illustration (Figures 32b, 32c) is a composite of Stolpe's drawings, photographs, and field notes augmented by personal knowledge of the Belfast barkcloth sculpture. The only difference between the Bayard and Sörling illustrations is that the Bayard profile is reversed. One main point of the Tattooed Man saga is that researchers must look at and evaluate with a critical eye all documents and illustrations purporting to be original.

Vaka Ariki probably traveled back and forth between Tahiti and Rapa Nui, perhaps via Mangareva, more than once during the 1870s and 1880s, and in 1904 he was again at Rapa Nui. He was sought out and photographed there during the Agassiz visit (Figure 32d). Vaka Ariki was well into his 60s by that time. He seems uninterested in the camera and his tattoos are so faded as to be barely visible.[73] Yet he remains a compelling presence.

When Katherine Routledge arrived at Rapa Nui on March 29, 1914, the population had increased to 250 persons. Routledge made a real effort to meet the elders of the community. She came to know Juan Tepano and Veriamo, his mother, well. She also knew of Juan's sister in the leper colony.[74] Although she was aware of the three marriages of Veriamo, Routledge never mentioned Vaka Ariki by name in her publications or field notes. Perhaps he had departed the island again or was no longer alive.[75] Perhaps he was no longer interested in talking to visitors. To this day, however, his biographical legacy is a key component of the illustrated history of Rapa Nui. The haunting presence of his tattooed face is no less iconic than the many stone faces of the statues his ancestors carved.

FIGS. 32A–D

Composite illustration of four depictions of the Tattooed Man, 1877–1904:

A. *Engraving, Émile Bayard, 1877 (detail of Figure 22a, p. 20);*

B. *Photo engraving (reversed), Wilhelm Fredrik Meyer and Carl Olof Sörling (Stolpe 1899, 4; Figure 2, p. viii);*

C. *Photograph (reversed), Hjalmar Stolpe and Oscar Elkholm, Tahiti, undated (1884?) (Figure 3, p. 1);*

D. *Photograph, Tattooed Man Easter Island, USS Albatross, 1904 (detail of Figure 5, p. 3).*

A B C D

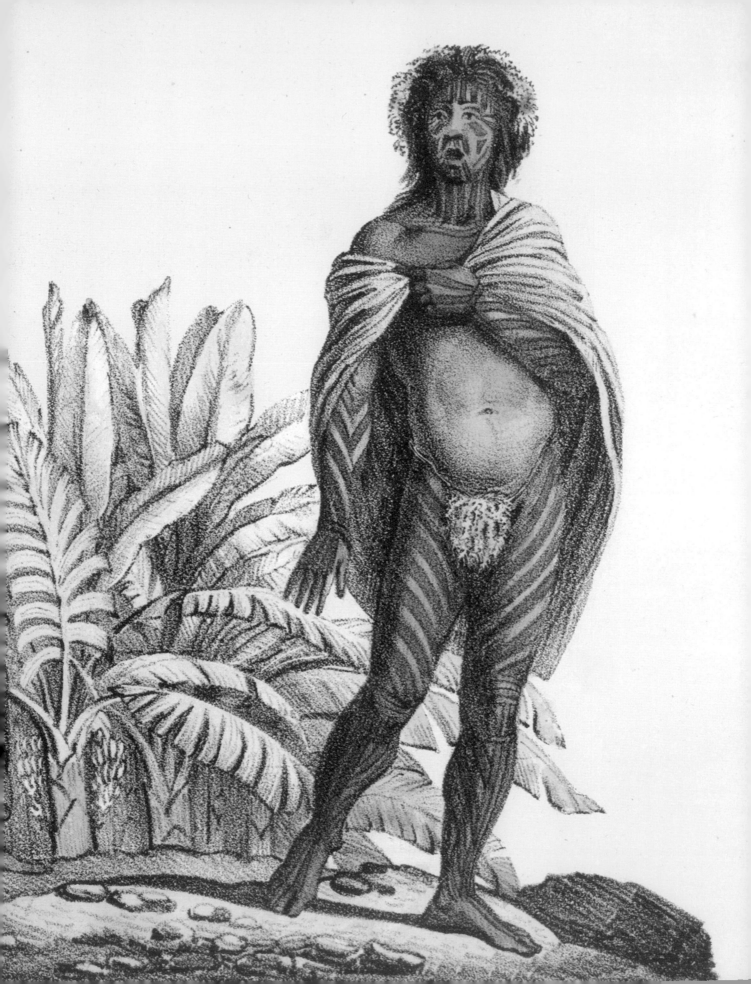

ACKNOWLEDGMENTS

This volume, the first in an edited series of illustrated essays on Rapa Nui and Polynesian art, was made possible by the generosity of the Easter Island Statue Preservation Foundation (EISP) and a contribution from Johannes Van Tilburg. Alberto Hotus shared ethnographic insights; Elena Mazuela Hucke provided her family history; Mark and Carolyn Blackburn, Honolulu, allowed the use of images in their collection; Hermann Mückler provided data from the manuscript of his subsequently published text; Cristián Arévalo Pakarati illustrated the barkcloth figures; Alice Hom produced the illustrated map and managed the text and image files; Yeisi Pinochet produced the two composite illustrations (Figures 26a–d and 32a–d) and facilitated email correspondence and contacts. Audrey Kopp copyedited a preliminary draft, which also benefited from the comments of Grant McCall and two anonymous reviewers; Jacob W. Love provided copyediting assistance; and Robert Assmus facilitated copyediting and communication with Barbara Pope Book Design.

The museum professionals who provided documentation or imagery include Jessica Desany Ganong, imaging services coordinator, Peabody Museum of Archaeology and Ethnology, Harvard University; Father Paul Lejeune, Archivio Generale SSCC, Rome; Claude Stéfani, conservator of Musées Municipaux de Rochefort; Bénédicte Lafarge, documentation of collections, Mairie de Rochefort, Musées Municipaux, Musée d'Art et d'Histoire (Maison de Pierre Loti); Philippe Peltier, Musée du Quai Branly; Sylviane Bonvin Pochstein, in charge of collections of ethnography, Muséum de Toulouse; Maggie Dittemore, anthropology librarian, Smithsonian Institution; Janet Stanley, librarian for the National Museum of African Art, Smithsonian Institution; B. J. Short, Bernice Pauahi Bishop Museum, Honolulu; the staff at the Bildarkiv Etnografiska museet, Sweden; Martin Schultz, Statens Museer för Världskultur; the staff at the British Museum, London; Joy Wheeler, Assistant Picture Librarian, Royal Geographical Society (with the Institute of British Geographers), London; Rachel Hand, University Museum of Archaeology and Anthropology, Cambridge, UK; and the staff at the Los Angeles County Museum of Art.

OPPOSITE
*Lithograph after drawing by Louis Choris
(detail of Figure 8, p. 6).*

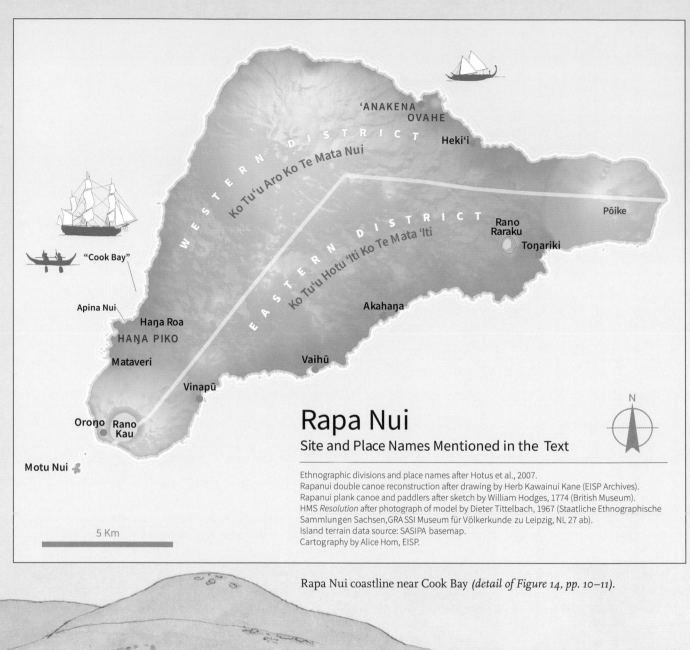

Rapa Nui
Site and Place Names Mentioned in the Text

'ANAKENA
OVAHE
Heki'i

WESTERN DISTRICT

Ko Tu'u Aro Ko Te Mata Nui

"Cook Bay"

EASTERN DISTRICT

Ko Tu'u Hotu 'Iti Ko Te Mata 'Iti

Pōike

Rano Raraku

Toŋariki

Akahaŋa

Apina Nui

Haŋa Roa

HAŊA PIKO

Vaihū

Mataveri

Vinapū

Oroŋo
Rano Kau

Motu Nui

N

Ethnographic divisions and place names after Hotus et al., 2007.
Rapanui double canoe reconstruction after drawing by Herb Kawainui Kane (EISP Archives).
Rapanui plank canoe and paddlers after sketch by William Hodges, 1774 (British Museum).
HMS *Resolution* after photograph of model by Dieter Tittelbach, 1967 (Staatliche Ethnographische
Sammlungen Sachsen, GRASSI Museum für Völkerkunde zu Leipzig, NL 27 ab).
Island terrain data source: SASIPA basemap.
Cartography by Alice Hom, EISP.

5 Km

Rapa Nui coastline near Cook Bay *(detail of Figure 14, pp. 10–11).*

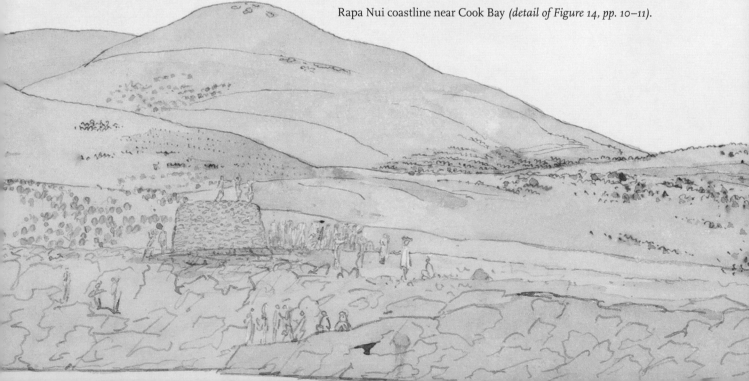

GLOSSARY

The Polynesian name for Easter Island is Rapa Nui, but the name of the language and the people is spelled Rapanui. Place names have variant spellings depending on the literature consulted, and our map and text employ generally accepted diacritical markings that distinguish the Rapanui language, including the nasal (ŋ) and, if well-attested, the glottal stop ('). The plural of Rapanui words is not formed by adding the letter "s," but is inferred from the context of the English language sentence. Rapanui words in quotations follow the original rendering in the source referenced.

RAPA NUI PLACE NAMES

ʻAnakena. Seat of paramount chief; royal Miru estate

Akahaŋa or **Akahanga.** Major ceremonial site; Ahu Akahaŋa is associated with Hotu Matuʻa (also written Hotu a Matuʻa)

Apina Nui. Coastal locale between the modern village of Haŋa Roa and Mataveri

Haŋa Piko or **Hanga Piko.** Main port

Haŋa Roa or **Hanga Roa.** Modern village and the bay on which it is situated

Hekiʻi. Major ceremonial site; Ahu Hekiʻi is associated with the royal estate

Mataveri. Secondary site of Oroŋo ceremonies; colonial ranch headquarters

Motu Nui. Islet off Rano Kau; associated with "birdman" ceremonies

Oroŋo or **Orongo.** Ceremonial "birdman" site located on Rano Kau; also written as ʻOroŋo

Ovahe. Bay and adjoining lands; associated with the royal estate

Rano Kau. Primary site of Oroŋo "birdman" ceremonies

Rano Raraku. Monolithic statue quarry; also written Rano a Raraku

Toŋariki or **Tongariki.** Largest ceremonial site; associated with Hotu Iti

Vaihū. Major ceremonial site; Ahu Vaihū

Vinapū. Major ceremonial site; Ahu Tahiri

SELECTED RAPANUI WORDS

ahu. Raised, rectangular stone ceremonial platform; see *moai*

ʻao. Anthropomorphized, ceremonial wood dance paddle

ariki. Chief (Miru)

ariki mau. Paramount chief (Miru)

hami. Clothing; loincloth

hare. House

hare paʻeŋa. Higher-status elliptical house with cut and dressed stone foundation; see *hare*

hare vaka. Lower-status elliptical house with stone foundation; see *hare*

hopu. Young, athletic men able to represent the chief by participating in the arduous aspects of the competitive "birdman" rituals

humu. Tattoo pattern of dots on forehead; see *puraki*

kohau roŋoroŋo. Class of wood object embellished with miniature symbols

komari. Tattoo pattern of vulva; vulva symbol on wood or stone

kona. Tattoo pattern of lines or circles; surface to be tattooed; see *takona*

kumara. Sweet potato (*Ipomoea batatas*)

mahute. Paper mulberry tree (*Broussonetia papyrifera*); the bark is used throughout the Pacific in making barkcloth

maori. Expert artisan

manu. Bird

manutara. Sooty tern (*Sterna* sp.); sacred bird

mata. Patrilineal kinship group; eye

miro puauhu. Wood tattoo mallet

Miru. Ruling sociopolitical group; second son of founding ancestor, Hotu a Matuʻa

moai. Stone statue, monolithic; carving; see *ahu* and *moai maʻea*

moai kavakava. Class of anthropomorphic wood carvings

moai maʻea. Stone statue, nonmonolithic; see *moai*

moko. Lizard; class of anthropomorphized wood carvings

paʻeŋa. Individual family group

paʻoa, paoa. Warrior; class of wood clubs

pora. Tied reed bundle used as a float by *hopu* in Oroŋo ceremonies

puauhu. Bone tattoo mallet

puraki. Tattoo pattern of dots on forehead; see *humu*

rei miro. Wood gorget

retu. Tattoo pattern; curved lines on face

ta. Lit. to strike; tattoo or tattooing; see *takona* and *kona*

tahoŋa. Class of egg-shaped or coconut-shaped wood carvings

takona. Tattoo or tattooing; see *kona* and *ta*

taŋata manu. Birdman

toki. Tattoo motif; stone adze

ua. Class of anthropomorphized wooden staves; also, elaborate linear throat, nose, and neck tattoo motifs

uhi. Bone tattoo needle

umi umi. Tattoo pattern; two or three vertical lines on chin

ure. Lit. penis; lineage or family

vaka. Canoe; watercraft

NOTES

1. Our article corrects the record in which a caption of the Stolpe drawings misidentified the Tattooed Man as "Rano, later called Tepano" (Van Tilburg 1994, 117, Fig. 9; Van Tilburg 2002, 290, n. 129) and an editorial error in another caption in which the Metropolitan Museum of Art misidentified him as "Juan Tepano" (Kaeppler 2002, 37, 38, Fig. 18). The reader should be forewarned that websites dealing with Rapanui tattoo are filled with such errors and misinterpretations.

2. Juan (Iovani) Tepano a Rano (Parare'e) was the son of Victoria Veriamo a Huki a Parapara (hereafter Veriamo) and her third husband, Rano (McCall 1986; Hotus et al. 1988, 133, 138; Van Tilburg 2003, 129, 290). In a legal declaration made on August 7, 1914, Juan Tepano stated that his age was 38, making his birth year 1876 (Hotus et al. 1988, 319). Métraux (1940, 3) says that Juan Tepano was "about 60" in 1934–35, making his birth year about 1874–75. McCall (personal communication, 2016) says that Juan Tepano was baptized in 1872. Métraux (1940, 3) also says that Veriamo was "over 100 years old" in 1934–35, making her birth year about 1834–35. Ages of Rapanui people are generally overestimated, and Veriamo's age suggests to some that she was Juan Tepano's grandmother, not his mother. However, Routledge (1919, 228) referred to Veriamo as Juan Tepano's mother. Veriamo is one of two tattooed Rapanui women named in the ethnographic literature. At least five to eight of her tattooed contemporaries are not named in Knoche (1925).

Rano and Veriamo (Juan Tepano's parents) were of the Ko Tu'u Hotu Iti patrilineal kinship group (*mata*). Routledge (1919) gives the spelling as Ko Tuu (without the glottal), and Métraux gives it as Tuu (1940, Fig. 1); it is Tu'u in Hotus et al. (1988, 2013, 8), Métraux (1940), McCall (1990, 1994, 1998), and McCoy (1976, 126–28). Hotus et al. (2013, 7) defines *mata* as *confederaciones* or "confederations." Routledge (1919, 221, Fig. 9) defines it as "clan," and Métraux (1940, 120) prefers "tribe." Each of the two confederations was associated with a cardinal direction (west or east), as well as with ancestral names and their associated ranks. Major landmarks and ceremonial sites (*ahu*) distinguished territories. The confederations were made up of lineage groups (*ure*) and occupied by individual families (*pa'eŋa*).

3. HMS *Vanadis* arrived at Hawai'i from Tahiti on June 20, 1884, and departed July 10, 1884. Aboard the vessel was Prince Oscar of the United Kingdom of Sweden and Norway. His royal visit was a major occasion in Hawai'i. Culin (1906) in his obituary of Stolpe dates the circumnavigation of the *Vanadis* to 1883–85.

4. "Ich photographirte ihm von forn und von der Seite" (Stolpe 1899, 4).

5. The expedition arrived at Rapa Nui from Callao December 15, 1904, and laid off the island for five days (Agassiz 1913).

6. Nicoll (1908, 195), who arrived at Rapa Nui aboard the *Valhalla*, describes local guides as either Tahitians or people who had lived in Tahiti for a long time and spoke or understood Tahitian.

7. "Er war ein schöner, ziemlich krättiger Mann mit hoher Stirn, funkelnden Augen, Adlernase und unverhältnissmässig kräfrigem Bartwuchse" (Stolpe 1899, 4).

8. Stolpe (1899, 7–8, Fig. 10) first published an image of the arm tattoo; Métraux (1940, 246, Fig. 35a) and Van Tilburg (2006, 37, 290, n. 129) also published images. Hoa Hakananai'a (also rendered as Hoahakananai'a) is embellished on its dorsal side with incised and carved motifs.

9. Van Tilburg (2006, 37) identifies the first officer as Lieutenant Lang and speculates that the "dancing chief" is Torometi, who negotiated the removal of Hoa Hakananai'a. It is unlikely that the "dancing chief" was the Tattooed Man, as Palmer would most likely have described or depicted him, and he did not.

10. "About fifteen years before" is 1869, so the Tattooed Man was off by one year (Stolpe 1899, 4–5). The *Vanadis* arrived in Tahiti in May 1884.

11. Van Tilburg (2006) discusses the linkage between Hoa Hakananai'a and the western sociopolitical region, based on a speculative boundary line described by Routledge. McCoy

(1976, 109, Fig. 46) suggests that the archaeological markers of the boundary were at Oroŋo, and Hotus et al. (1988, 2013, 8) suggests that such markers occur islandwide.

12. Hotus et al. (1988); Corney (1908); Tuʻu refers to the Tuʻu Aro or combined, higher-ranked western groups (ure). Hotu Iti refers to the similarly combined, lower-ranked eastern groups known as Hotu ʻIti Ko Te Mata ʻIti.

13. Métraux (1940, 226–48) reviews early observations of tattoo. He draws from Routledge (1919, 219, Figs. 88, 114), who gives some names of tattoo patterns, obtained from Juan Tepano. Routledge includes other patterns, the names of which she questioned, in her unpublished field notes.

14. Van Tilburg (1992, 198, Figs. 76, 77); the illustration depicts trade goods (a mirror and a hatchet) for the first time.

15. Métraux (1940) gives 1816 as the arrival date of this Russian ship; however, see Biblioteca William Mulloy [McCall G.], n.d. [1986?], MSS MA 364.

16. Fischer (1991, 303).

17. Van Tilburg (1992, 36, citing Public Records Office 38/8762; Supernumerary Complete Book, May 26, 1850, to May 13, 1854). Public Records Office Administration 104/24 has J. Linton Palmer aboard HMS Portland on April 5, 1853. The Navy List has Palmer assigned to HMS Portland on February 17, 1851. His continued assignment to HMS Portland in 1852 is not specifically stated (Dorota Starzecka, personal communication with Jo Anne Van Tilburg, 1991; Easter Island Statue Project Archives).

18. First published in McCall (1980, frontispiece); Van Tilburg (1992, 36, citing Public Records Office Administration 53/4419, September 7, 1852–March 14, 1853).

19. Biblioteca William Mulloy [McCall, G.], n.d. [1986?], MSS MA 364 incorrectly gives Rear Admiral Frederick Proby Doughty as Rear Admiral Frederic Proby.

20. Mückler (2015) notes that a tattooed woman, 90 years old, told Knoche (1925) that she could still remember the Peruvian slave traders.

21. Torometi and his men were known as mutoi (guards or police) in Tahitian and were in the tradition of the Rapanui warriors (paʻoa or paoa), who acted as chiefly bodyguards armed with emblematic clubs; they are sometimes referred to as war chiefs (cf. Englert 1996, 61–71, with annotations). Brother Eyraud (Altman 2004, 2005) definitely characterized Torometi as a chief.

22. Routledge's (1919, 289) principal consultant on legends was Gabriel Revahiva, also known as Kapiera (Barthel 1974).

23. The major genealogical source is Hotus et al. (1988, 2013); for Rapanui departures for Tahiti, see McCall (1986). Muñoz (2015, 6, Tables 1, 2) cites McCall (1976) for the same data we cite as McCall (1986).

24. Muñoz (2015, 7) cites Anguita (1986, 114), who "claims that all of them had 'signed' employment contracts for periods of three to five years to work for Brander."

25. Ayres and Ayres (1995, 7) write "Alexander Paea Salmon" and describe him as a "half-Tahitian who managed the Brander ranch holdings" on Rapa Nui. They note that "Salmon's role was crucial" but that "Geiseler is not always clear about whether his information was derived only from Salmon, from others using Salmon as interpreter, or from others directly."

26. This is in contrast to George Forster (Kahn 1986, 323–24), who says: "They were all prodigiously punctured on every part of the body, the face in particular; and their women, who were very small and slender limbed, had likewise punctures on the face, which resembled the patches sometimes worn by our ladies."

27. The statue collected by USS Mohican for the Smithsonian Institution has an incised design on its torso (Van Tilburg 2006).

28. By "highest," Thomson means more elaborate and/or of higher status.

29. The man named Mati whom Thomson describes (1891, 461) would have been born in 1796. In 1886, when Mati was about 90 years old, Juan Tepano would have been a child of about 10 years. The same or another man named Mati was an 82-year-old chief in 1878 (Biblioteca William Mulloy [McCall G.], n.d. [1986?], MSS MA 364). A man named Mati (Petero) is of the Atamu-Atam-Atan line of the Koro o Roŋo mata, and another man named Nga Mati is of the Raʻa mata. Mati (Petero) was the son of Rutirangi and had a sister named Maria and a cousin named Atamu Hare Kai Hiva. Those names are in accord with the names Atamu, Petero, and Maria Julien Viaud (Pierre Loti) gave in 1872 to his contacts in the Haŋa Piko area. Muñoz (2015, 8, Table 3) has Petero Mati on Bishop Jaussen's list of Rapanui land purchases in Pamatai, Tahiti.

30. Very general population estimates by Europeans are all speculative based on numbers of people gathered on shore and range from about 2,000 to 3,000 for the ʻAnakena area in 1770 to a low of about 600–700 for the Cook Bay area in 1774. Population estimates rose to approximately 2,000 in 1786 and then

fell into a steady decline to 1864 and the precipitous drop documented by the missionaries. McCall (1986) estimates 600 persons in 1870.

31. Métraux (1940, 241, Fig. 32; Ayres and Ayres 1995, 150, 191, n. 144, inventory nos. 37, 81). Mückler (2015) describes the dye as burned leaves of the *ti* plant, as did Métraux (1940).

32. The colonial administration named her queen, but she was not of royal lineage.

33. The count d'Artagnan is the fictional character in *The Three Musketeers*, the first of a series of three romantic novels published in 1844 by Alexandre Dumas. The comparison of Pinart to d'Artagnan originated with Morgan and Hammond (1963, 81), who say Pinart "would have seemed a dashing figure, for a drawing of him at Easter Island shows him looking like a cross between Stanley and d'Artagnan. He was a tall, athletically built man with dark, somber eyes, a patrician nose and a thick flowing beard with a full, rather sensual mouth." H. M. Stanley (1842–1904) was a Welsh journalist who went to central Africa in search of the missionary David Livingstone (1813–1873). Upon finding him, Stanley claimed to have greeted him with, "Dr. Livingstone, I presume?"

34. See obituaries in Balfour (1927); Stolpe (1883, 1890, 1899).

35. Gustave Viaud also shot portraits, including *La Reine de Bora Bora* (O'Reilly 1969, 18, Fig. 7).

36. For an account of Viaud's (Loti's) photographs in Africa and Asia, see Quella-Villéger and Vercier 2010 (con. Altman 2004, 2005), in which a note by Georgia Lee incorrectly states that in 1872, "cameras and the stereopticon have not yet been invented." For a description of the equipment necessary for photography in 1842, see O'Reilly (1969, 11, Fig. 2).

37. For an 1896 view of rue de la Petite-Pologne, see O'Reilly (1969, 43, Fig. 37).

38. It is not known if C. B. Hoare was present when Julien Viaud (Loti) called at the Petite-Pologne Street studio. Viaud arrived in Tahiti on January 29, 1872, and C. B. Hoare may have departed in January 1872 for San Francisco. C. B. Hoare is mentioned in the context of business dealings with C. D. Voy in 1875 and with Thomas Croft in June 1877.

39. The objects include a ceremonial dance paddle ('ao), two gorgets (*rei miro*), a prominently displayed *kohau roŋoroŋo* known as "Keiti," a stave (*ua*), an egg-shaped carving or *tahoŋa*, and an anthropomorphic figure. The setting is the mission residence; the group is said to be Bishop Jaussen's house staff, and the priests are identified as Father George Eich and Brother Théodule Escolan, with Bishop Jaussen at the window (Fischer 1997, 15, Fig. 4; McCall 1980, 140).

40. Father Paul Lejeune, Archivo Generale SSCC (personal communication, Adrienne L. Kaeppler, December 11, 2015), states that the Archivo holds "about 30 photos signed by Hoare." The photo reproduced in Orliac and Orliac is "a very old photo taken in 1873. On the photo and also on the copies we have, there is no indication that it's been done by Hoare." He further states, "I do not know where this reference has been found."

41. George Davidson (1825–1911), renowned for his work with the U.S. Coastal Survey, was president of the California Academy of Sciences 1871–85 (Charles D. Yale 1885, accessed November 19, 2017, http://www.history.noaa.gov/giants/davidson.html).

42. Fischer (1997, 58–60) paraphrases Croft's descriptions of these same events and speculates that the "informant" in question may have been Metoro (Campbell 1990, 87), a Rapanui man conversant with *roŋoroŋo* who interpreted for Bishop Jaussen. McCall (personal communication, 2016) states that "this account by Croft is identical to that of Jaussen in dealing with 'Metoro,' a Rapanui gardener quite likely in the photograph in question."

43. Parmenter (1966) provides a descriptive bibliography of Pinart's works, and Kaeppler (2001, 268, n. 7) documents the whereabouts of objects in Pinart's collections. Twenty-three volumes of Pinart's papers are on file at the Bancroft Library, University of California, Berkeley: Pinart, Alphonse Louis (1852–1911), correspondence and papers, 1870–95: BANC MSS Z-Z 17, "Fragmentary Diaries" vols. 3–14, including Tahiti and Easter Island (January 18–April 26, 1877), and 2 vols. "Vues et inscriptions de l'île de Pâques" by P. Loti. Pinart's sketches are of *moai* in Rano Raraku, and most are on the exterior slopes and quarries.

44. All but one illustration in Pinart (1878a) are by de Bar. A carved wood figure (*kavakava*) drawn by de Bar is based on a photograph acquired in Tahiti or taken by Lucien-Joseph Berryer.

45. From the Bancroft Library: Pinart, Alphonse Louis (1852–1911).

46. Kaeppler published cartes de visite photos of these and other officers on the *Seignelay* (2001, 261, Fig. 1).

47. Con. Fischer (2005, 121; n. 71); McCall (1994, 86) states that Pinart "brought a photographer to the island, E. Bayard, who made a series of studies resulting in a tableau of the French crew being received" at Mataveri. The photographer with Pinart was not in fact Bayard; it was Lucien-Joseph Berryer.

48. Altman (2004, 2005) inserts illustrations that are not from Pinart; others are unattributed or out of chronological order, causing confusion.

49. Routledge (1919, 219, Fig. 88) gives a composite illustration from rough notes.

50. Grant McCall (personal communication, 2016).

51. Meroz (2004) reprints the letter from Thomas Croft to Alphonse Pinart. We have read the original letter in the Bancroft Library: Pinart, Alphonse Louis (1852–1911).

52. Thomas Croft further draws Pinart's attention to the photo he (Croft) took of an engraving in a *Harper's Weekly* (April 26, 1873) article by Julien Viaud (Pierre Loti). The engraving is a frequently reproduced, imaginary composition showing six standing statues and a vast gathering of people participating in a ritual performance.

53. So far as we know, the Tattooed Man was never in the employ of the mission (see n. 39). However, we wondered whether Thomas Croft could have taken the Tattooed Man photo (Figure 3, p. 1) and given it to Pinart, who then, because of its poor quality, donated it to some group or institution in Hawai'i, where Stolpe acquired it. We abandoned this line of inquiry because neither of the major modern Hawaiian institutions with interests in Pacific island history and ethnography existed at that time. Thus, it is obvious that the two photos are of the same individual, and, as we have noted above, it is the same person depicted in Figure 4.

54. Gordon Cumming (1882, 162, n. 2) describes a link between one branch of her Scottish relatives and the Branders through Lady Dunbar Brander.

55. Gordon Cumming met Alexander Salmon Jr. (Ari'ipaea) in Tahiti when he accompanied her as guide. Ari'ipaea was the son of the successful merchant Alexander Salmon (once secretary to Queen Pomare IV) and Taimai, a member of the royal family. Ari'ipaea took Dutrou-Bornier's place as John Brander's partner and manager until departing Rapa Nui in 1888 (McCall 1998, Fig. 2).

56. A drawing of a tattooed leg (Marquesan) is among "about 30 photos signed by Hoare" (Father Paul Lejeune, Archivo

Generale SSCC; personal communication, Adrienne L. Kaeppler, December 11, 2015).

57. Gordon Cumming (1882, 157) contrasted the *Nautilus* with the *Seignelay* and had no wish to make the journey to San Francisco on the smaller vessel. She also avoided sailing to San Francisco aboard the *Marama*, another of Brander's fleet, which went back and forth between Tahiti and Rapa Nui. It was about the same size as the *Nautilus*. She departed for Hawai'i on the *Paloma*, also belonging to John Brander.

58. Some of the people in the Bayard composite engraving appear to be Tahitian. Many photographs of Tahitians were available at the time. The native population of Tahiti in 1877 was about 3,000–4,000 (though one source gives 8,000). Europeans living there came and went, but knew one another and shared their contacts in the local community with visitors. For example, Gordon Cumming (1882, 233) met Bishop Jaussen through Mrs. Brander.

59. The thatched house was 1.5 meters high and 4 meters long, which is somewhat small for this relatively large group.

60. This translates to "five versions of the same image."

61. This translates to "a box containing drawings from Easter Island."

62. The preliminary drawing is a loose page originally in the collection of the Viaud-Loti family and now in the Musée d'Art et d'Histoire (Maison de Pierre Loti). The finished drawing and the engraving are both titled *Tatouages d'un chef*. The engraving was published in *L'Illustration* (Viaud 1872, 133) and the finished drawing is in a private collection (Bénédicte La Farge, personal communication with Adrienne L. Kaeppler).

63. The fully tattooed chief, Mati (Thomson 1891, 466), was about 76 years old in 1872 and cannot be ruled out as a possible candidate for the "old chief" whom Viaud (Loti) met. However, there is no documentation of his tattoo patterns and the only evidence in his favor is his age. Tago (the "old man" mentioned by Pinart in 1875) or Tori (d. before 1915) are also not viable options for the Tattooed Man; nor, as we have seen, are Roma (who was tattooed) and Torometi (who was not).

Another possible candidate we considered for the "old chief" is Tepano Rutiraṇi (also spelled Rutirangui). He lived in Tahiti and returned to Rapa Nui in 1888. According to Father Englert, he unwittingly introduced leprosy to the Rapanui population. He was eventually removed to a leper station north of Haṇa Roa. The elders there were considered cultural experts, and in 1914–15 Katherine Routledge consulted them about

roŋoroŋo. It is not known if Tepano Rutirangi was among those she met, nor is it known if he was tattooed.

One more potential match for the "old chief" is Rutiraŋi of the line Atamu, Atam, Atan, and the Koro Roŋo. His son was Mati (Petero), who in turn had a son, a daughter named Maria, and a nephew named Atamu Hare Kai Hiva (Atamou). Evidence against this identification is that Juan Porotu, a venerable descendant of another line of the same family and a consultant to Katherine Routledge, does not describe any of these individuals as tattooed.

64. Atamu Tekena (Te Kena) was the grandson of Te Kena, son of Hoŋa. His father was Vai Turi, and all were of the Miru. Specifically, there is the firstborn line; the second-born line, which died out; and the third-born line of Tekena (Métraux 1940, 90–91). Grant McCall (personal communication, 2016) states that Hoŋa and Tekena were "brothers/cousins; taina according to Englert and my informants. They represented two lines from the same family, forever competing." He further states that "Honga was Miru, Tekena was not" and notes that "I trust Englert and my informants, Mama Veri and Leon Tuki, but not Métraux" on the matter.

65. There is no certain evidence that Atamu Tekena was or was not tattooed. Tevo Pakarati, who created the bust of Atamu Tekena in the Haŋa Roa village square, said that there were no descriptions or photos from which he could work, and that the resultant sculpture was his own artistic statement.

66. Štambuk (2010, 60); Eva and Atamu Tekena had 14 children. One was Maria Aifiti (possibly the Marie that Viaud mentions). She married Nikolas Pakomio Angata and had a daughter named Vahiro (known as Elena Atan). Elena married Alberto Huki Make, and her daughter, Felicitas Huki Atan, is the mother of Elena Rosa Mazuela Hucke, who lived with the Van Tilburg family in California in 1987–92. Elena provided us with her generation's knowledge of Eva; see also Sepúlveda (1990).

67. According to Arredondo (2006, 59), José Fati, Erodia Pakarati, and Amelia Tepano all said that there were not four tattooed people alive in 1911, as Knoche (1925) claimed, but ten. Mückler (2015) says that "the pattern of lines on the face was identical in the two women, and corresponds to the description by Beechy and Geiseler."

68. Like Thomson, Palmer probably depicted the woman as younger or more attractive than the real person was.

69. Travel opportunities between Rapa Nui and Tahiti are based on notations of "immigrants," "natives," or "indigenènes" in the "remarks on purpose or principal events" found in Biblioteca William Mulloy [McCall G.], n.d. [1986?], MSS MA 364. Other information about the Rapanui people who immigrated to Tahiti to work for John Brander at Ha'apape or purchased lands in Pamatai from Bishop Jaussen is drawn from Muñoz (2015) and sources therein.

70. Grant McCall (personal communication, 2002) suggested Tepano Hakarevareva to Jo Anne Van Tilburg (2003, 299, n. 129); Muñoz (2015, 8, Table 2).

71. Alberto Hotus (personal communication, 2012) suggested Vaka Ariki to Adrienne L. Kaeppler; Ariki's nickname was Te A Papa (which means to pile up or make straight, as in sorting boxes in a warehouse). Recall that the Tattooed Man worked on the docks in Pape'ete.

72. Several well-informed Rapanui people told Jo Anne Van Tilburg that Veriamo's "first husband" was a terribly angry person and that he beat his wife mercilessly. Veriamo told Routledge that she had three husbands. The "first husband" the islanders refer to today is actually her second husband; that is, Vaka Ariki.

73. According to a Maori tattoo specialist, Ngahuia Te Awekotuku (personal communication, Adrienne L. Kaeppler, 2016), Polynesian tattoo fades after several years. By 1904, the tattoos created on Vaka Ariki would have been very faint.

74. Someone who arrived from Tahiti in 1888 introduced Hansen's disease (leprosy) to Rapa Nui. Thus Catalina's illness had 16 years to establish itself before Routledge's arrival in 1914. Routledge visited the leper station at least three times but does not mention Catalina by name.

75. The current Haŋa Roa village cemetery is one of four known modern burial grounds. One of the earliest contains unmarked graves and is marked by a single cross. It was in use in 1914–15.

REFERENCES

Agassiz, George Russell, ed. 1913. *Letters and Recollections of Alexander Agassiz with a Sketch of His Life and Work*. Boston: Houghton Mifflin.

Altman, Ann M., trans. 2004. *Early Visitors to Easter Island, 1864–1877: The Reports of Eugène Eyraud, Hippolyte Roussel, Pierre Loti, and Alphonse Pinart*. Los Osos, CA: Easter Island Foundation.

Altman, Ann M., trans. 2005. "A Look Back: Diary of a Cadet on the Warship *La Flore*—1872." Reprinted portion of *Early Visitors to Easter Island, 1864–1877: The Reports of Eugène Eyraud, Hippolyte Roussel, Pierre Loti and Alphonse Pinart*. *Rapa Nui Journal* 19 (2): 127–39.

Anguita, Patricia. 1986. "La migration Rapanui vers Tahiti et Mangareva (1871–1920)." Unpublished master's thesis, University of Paris.

Arredondo, Anna María. 2006. *Rapa Nui: Takona Tatu*. Santiago: Rapa Nui Press and the Padre Sebastián Englert Anthropological Museum Store.

Ayres, William S., and Gabriella S. Ayres, trans. 1995. "Geiseler's Easter Island Report: An 1880s Anthropological Account with an Introduction, Annotations, and Notes by W. S. Ayres." Asian and Pacific Archaeology Series 12. Honolulu: Social Science Research Institute, University of Hawai'i at Mānoa.

Balfour, Henry. 1927. Foreword to *Collected Essays in Ornamental Art by Hjalmar Stolpe*. Translated by Mrs. H. C. March. Stockholm: Aftonbladets Trykeri, iii–vii.

Barthel, Thomas S. 1974. *Das achte Land: Die Entdeckung und Besiedlung der Osterinsel nach Eingeborenentraditionen übersetzt und erläutert*. Munich: Klaus Renner Verlag.

Beechey, Frederick William. 1831. *Narrative of a Voyage to the Pacific and Beering's Strait, to Co-operate with the Polar Expeditions; Performed in His Majesty's Ship* Blossom, *under the Command of Captain F. W. Beechey, R.N., F.R.S. &c. in the Years 1825, 26, 27, 28*. London: Colburn and Bentley.

Biblioteca William Mulloy [McCall, Grant]. n.d. [1986?]. "Register of Visitors to Easter Island 1722 to 1900." MSS.MA 364. Haŋa Roa, Rapa Nui: Museo Antropológico Padre Sebastián Englert.

Campbell, Ramón, 1990. "Avances en el conocimiento de la escritura de la Isla de Pascua." In *Circumpacifica: Festschrift für Thomas S. Barthel*, vol. 2: *Ozeanien, Miszellen*, edited by Bruno Illius and Matthias Laubscher, 87–101. Frankfurt: Peter Lang.

Chauvet, Dr. Stephen. 1945. *La isla de Pascua y sus misterios*. Santiago: Pehuén Editores.

Churchill, William. 1917. *Club Types of Nuclear Polynesia*. Publication 255. Washington, DC: Carnegie Institution.

Conte Oliveros, Jesús. 1994. *Isla de Pascua: Horizontes sombrios y luminosos*. Santiago: Centro de Investigación de la Imagen.

Corney, Bolton Glanvill, trans. and ed. 1908. *The Voyage of Captain Don Felipe González in the Ship of the Line* San Lorenzo, *with the Frigate* Santa Rosalia *in Company, to Easter Island in 1770–1: Preceded by an Extract from Mynheer Jacob Roggeveen's Official Log of His Discovery of and Visit to Easter Island in 1722*. Nendeln, Liechtenstein: Kraus Reprint, 1967. First published by the Hakluyt Society (Cambridge).

Coutancier, Benoît. 1997. "Alphonse-Louis Pinart et la collection du musée de Boulogne-sur-Mer." In *La découverte du paradis: Océanie—curieux, navigateurs et savants*, edited by Association de conservateurs des musées du Nord–Pas de Calais, 197–201. Paris: Somogy Éditions d'Art.

Croft, Thomas. 1875. Letter to A. Pinart, April 30, 1874. *Proceedings of the California Academy of Sciences* 5 (21): 317–22.

Culin, Stewart. 1906. "Hjalmar Stolpe." *American Anthropologist* 8 (1): 150–56.

Darrah, William C. 1981. *Cartes de Visite in Nineteenth-Century Photography*. Gettysburg, PA: W. C. Darrah.

Englert, Sebastián. 1964. *Primer Siglo Cristiano de la Isla de Pascua*. Santiago de Chile: Imprent Salesiana.

Eyraud, José Eugenio. 2008. *Easter Island 1864*. Santiago: Imprenta Andina.

Fischer, Steven Roger. 1991. "Hugh Cuming's Account of an Anchorage at Rapa Nui (Easter Island), November 27–8, 1827." *Journal of the Polynesian Society* 100 (3): 303–15.

Fischer, Stephen R. 1997. *Rongorongo: The Easter Island Script History, Traditions, Texts*. Oxford Studies in Anthropological Linguistics 14. Oxford: Oxford University Press.

Fischer, Stephen R. 2005. *Island at the End of the World: The Turbulent History of Easter Island*. London: Reaktion Books.

Gordon Cumming, Constance Frederica. 1882. *A Lady's Cruise in a French Man-of-War*. Edinburgh: William Blackwood and Sons.

Gough, Barry M., ed. 1973. *To the Pacific and Arctic with Beechey: The Journal of Lieutenant George Peard of HMS Blossom, 1825–1828*. Cambridge: Cambridge University Press for the Hakluyt Society.

Hotus, Alberto, et al. (Consejo de Jefes de Rapa Nui). 1988. *Te mau hatu 'o Rapa Nui: Los soberanos de Rapa Nui—pasado, presente y futuro*. Santiago: Editorial Emisión y el Centro de Estudios Politicos Latinoamericanos Simón Bolivar.

Hotus, Alberto, et al. (Consejo de Ancianos Rapanui). 2013. *Te mau hatu o Rapa Nui: Los soberanos de Rapa Nui*. Santiago: Librería Monte Sarmento.

Kaeppler, Adrienne L. 2001. "Encounters with Greatness: Collecting Hawaiian Monarchs and Aristocrats." *History of Photography* 25 (2): 259–68.

Kaeppler, Adrienne L. 2002. "Rapa Nui Art and Aesthetics." In *Splendid Isolation: Art of Easter Island*, edited by Eric Kjellgren, 32–41. New York: Metropolitan Museum of Art.

Kaeppler, Adrienne L. 2003. "Sculptures of Barkcloth and Wood from Rapa Nui: Symbolic Continuities and Polynesian Affinities." *RES: Anthropology and Aesthetics* 44 (Autumn): 10–69. Cambridge, MA: Harvard University Press.

Kaeppler, Adrienne L. 2010. *Polynesia: The Mark and Carolyn Blackburn Collection of Polynesian Art*. Honolulu: Mark and Carolyn Blackburn.

Kahn, Robert L., ed. 1986. *A Voyage Round the World. Georg Forsters Werke*, vol. 1, Sämtliche Schriften, Tagebucher, Briefe. Berlin: Akademie-Verlag.

Knoche, Walter. 1925. *Die Osterinsel: Eine Zusammenfassung der chilenischen Osterinselexpedition des Jahres 1911*. Concepción: Verlag des Wiss, Archivs von Chile.

Laracy, Hugh. 2012. "Constance Frederika Gordon-Cumming (1837–1924): Traveller, Author, Painter." In *Watriama and Co.: Further Pacific Island Portraits*, 69–92. Canberra: Australian National University Press.

Lavachery, Henri Alfred. 1939. *Les pétroglyphes de l'île de Pâques, ouvrage publié avec le concours de la fondation universitaire de Belgique*. Antwerp, Belgium: De Sikkel.

Loti, Pierre [Julien Viaud]. 1899. *Reflets sur la sombre route*. Paris: Calmann-Lévy.

Loti, Pierre [Julien Viaud]. 1988a. *L'île de Pâques: Journal d'un aspirant de* La Flore. Edited by Pierre-Olivier Combelles. Paris: Éditions Pierre-Olivier Combelles, 61–115. First published in Pierre Loti [Julien Viaud], *Reflets sur la sombre route*, 1899.

Loti, Pierre [Julien Viaud]. 1988b. "Introduction." In *L'île de Pâques: Journal d'un aspirant de* La Flore. Edited by Pierre-Olivier Combelles. Paris: Éditions Pierre-Olivier Combelles, 13–20.

Loti, Pierre [Julien Viaud]. 1988c. "Journal intime 3–8 Janvier 1872." In *L'île de Pâques: Journal d'un aspirant de* La Flore. Edited by Pierre-Olivier Combelles. Paris: Éditions Pierre-Olivier Combelles, 21–59.

Loti, Pierre [Julien Viaud]. 1988d. "Lettres de Julien Viaud (Pierre Loti) à sa soeur Marie." In *L'île de Pâques: Journal d'un aspirant de* La Flore. Edited by Pierre-Olivier Combelles. Paris: Éditions Pierre-Olivier Combelles, 117–20.

McCall, Grant. 1976. "Reaction to Disaster: Continuity and Change in Rapanui Social Organization." Dissertation, Australian National University.

McCall, Grant. 1980. *Rapanui: Tradition and Survival on Easter Island*. Honolulu: University of Hawai'i Press.

McCall, Grant. 1986. "Las fundaciones de Rapanui." Haŋa Roa, Rapa Nui: Museo Provincial R. P. Sebastián Englert, Isla de Pascua, Chile. Manuscript translated by Lilian González Nualart and Gaston Vera.

McCall, Grant. 1990. "Rapanui and Outsiders: The Early Days." In *Circumpacifica: Festschrift für Thomas S. Barthel*, vol. 2: *Ozeanien, Miszellen*, edited by Bruno Illius and Matthias Laubscher, 165–225. Frankfurt: Peter Lang.

McCall, Grant. 1994. "Rapanui Images." *Pacific Studies* 17 (2): 85–102.

McCall, Grant. 1998. "Rapanui Wanderings: Diasporas from Easter Island." In *Easter Island in Pacific Context: South Seas Symposium*, edited by Christopher Moore Stevenson, Georgia Lee, and F. J. Morin, 370–78. Los Osos, CA: Easter Island Foundation.

McCoy, Patrick Carlton. 1976. "Easter Island Settlement Patterns in the Late Prehistoric and Protohistoric Periods." *Bulletin* 5. New York: Easter Island Committee, International Fund for Monuments.

Meroz, Yoram. 2004. "Early Speculations on Rapanui: Thomas Croft to Alphonse Pinart, 1876." *Rapa Nui Journal* 18 (1): 56–57.

Métraux, Alfred. 1940. *Ethnology of Easter Island*. Bernice P. Bishop Museum Bulletin 160. Honolulu: Bishop Museum Press.

Morgan, Dale L., and George P. Hammond. 1963. *A Guide to the Manuscript Collections of the Bancroft Library*. Berkeley: University of California Press.

Mückler, Hermann, ed. 2015. *Walter Knoche—Die Osterinsel: Die Chilenische Osterinsel-Expedition von 1911*. Wiesbaden: Otto Harrassowitz.

Muñoz, Diego. 2015. "The Rapanui Diaspora in Tahiti and the Lands of Pamatai (1871–1970)." *Rapa Nui Journal* 29 (2): 5–22.

Nicoll, Michael John. 1908. *Three Voyages of a Naturalist: Being an Account of Many Little Known Islands in Three Oceans Visited by the* Valhalla, *RYS*. London: Witherby.

O'Reilly, Patrick. 1969. *Les photographes à Tahiti et leurs oeuvres 1842–1962*. Paris: Société des Océanistes, Musée de l'Homme.

Orlebar, J. 1976. *A Midshipman's Journal on board H.M.S. Seringapatam, during the year 1830; containing observations of the Tonga islands and other islands in the South Sea*. San Diego, CA: Tofua Press. Originally published in 1833 by Whittaker, Treacher, London, under title: *A midshipman's journal, on board H.M.S. Seringapatam, during the year, 1830, containing brief observations on Pitcairn's Island, and other islands in the South Sea*.

Orliac, Michel, and Catherine Orliac. 2008. *Tresors de l'île de Paques: Collection de la congregation des Sacrés-Coeurs de Jésus et de Marie SSCC*. Translated into English by Paul Bahn. Paris: Editions Louise Leiris.

Parmenter, Ross. 1966. *Explorer, Linguist, and Ethnologist: A Descriptive Bibliography of the Published Works of Alphonse Louis Pinart, with Notes on His Life*. Los Angeles: Southwest Museum.

Pelletier, Micheline avec Sonia Haoa Cardinali, Photographies de Micheline Pelletier. 2012. *Île de Pâques: Terra incognita*. Editions de La Martinière.

Pinart, Alphonse Louis. 1878a. "Voyage à l'île de Paques (Océan Pacifique)." Paris: *Le Tour du Monde*, dix-neuvième année, 2nd semester: 225–40.

Pinart, Alphonse Louis. 1878b. "Exploration de l'île de Paques." Paris: *Bulletin de la Société de Géographie* series 6 (16): 193–213.

Prat, Fr. Venance. 2015. *Vie de Monseigneur Tepano Jaussen, évêque de Axiéri, 1er vicaire apostolique de Tahiti*, vol. 1. Papeete: Éditions Univers Polynesiens.

Proceedings of the California Academy of Sciences, vol. 5, 1875. San Francisco: The Academy.

Quella-Villéger, Alain, and Bruno Vercier. 2010. *Pierre Loti Dessinateur: Une oeuvre au long cours*. Paris: Bleu Autour.

Roe, Michael. 1967. *The Journal and Letters of Captain Charles Bishop on the North-West Coast of America, in the Pacific and in New South Wales, 1794–1799*. Cambridge: Cambridge University Press for the Hakluyt Society.

Routledge, Katherine. 1917. "The Bird Cult of Easter Island." *Folk-Lore: Transactions of the Folklore Society* 28 (4).

Routledge, Katherine. 1919. *The Mystery of Easter Island: The Story of an Expedition*. London: Hazell, Watson, and Viney.

Sepúlveda, Milo. 1990. *Rapa Nui, 100 años: Reportaje a la última frontera*. Santiago: Ediciones Aku-Aku.

Štambuk, Patricia. 2010. *Rongo: La historia oculta de isla de Pascua*. Santiago: Pehuén Editores.

Smith, Bernard. 1950. "European Vision and the South Pacific." *Journal of the Warburg and Courtauld Institutes* 13: 65–100.

Smith, Bernard. 1985. *European Vision and the South Pacific*. New Haven, CT: Yale University Press.

Smith, Bernard. 1992. *Imagining the Pacific: In the Wake of the Cook Voyages*. New Haven, CT: Yale University Press.

Stolpe, Knut Hjalmar. 1883. *Påsk-ön I Stilla oceanen: Anteckningar*. Stockholm: A. L. Normans.

Stolpe, Knut Hjalmar. 1899. "Über die Tätowirung der Oster-Insulaner." In *Festschrift für A. B. Meyer*, edited by K. M. Heller. *Abhandlungen und Berichte des Königl. Zoologischen und Anthropologisch-Ethnographischen Museums zu Dresden 1899*, band 8 (6): 1–13. Berlin: R. Friedländer & Sohn. Translated into English by Heinz Gerstle. Translated manuscript on file, Easter Island Statue Project Archives.

Tee, Garry J. 2010. "The Elusive C. D. Voy." *Journal of the Historical Studies Group*, Geological Society of New Zealand: 1–11.

Thomson, William Judah. 1891. *Te Pito te Henua, or Easter Island*. From the report of the National Museum, 1888–89, 447–558.Washington, DC: Smithsonian Institution.

Tréhin, Jean-Yves. 2003. *Tahiti: L'Eden à l'épreuve de la photographie—une histoire de la photographie à Tahiti et dans les îles, 1859–1940*. Paris: Gallimard.

Van Tilburg, Jo Anne. 1992. *HMS Topaze on Easter Island*. Occasional Paper 73, British Museum Department of Ethnography. London: British Museum Press.

Van Tilburg, Jo Anne. 1994. *Easter Island Archaeology, Ecology and Culture*. London: British Museum Press.

Van Tilburg, Jo Anne. 2002. "Changing Faces: Rapa Nui Statues in the Social Landscape." In *Splendid Isolation: Art of Easter Island*, edited by E. Kjellgren, 24–31. New York: Metropolitan Museum of Art.

Van Tilburg, Jo Anne. 2003. *Among Stone Giants: The Life of Katherine Routledge and Her Remarkable Expedition to Easter Island*. New York: Scribner's.

Van Tilburg, Jo Anne. 2006. "Remote Possibilities: Hoa Hakananai'a and HMS *Topaze* on Easter Island." British Museum Research Publication 158. London: British Museum Press.

Van Tilburg, Jo Anne. 2014. "Lost and Found: Hoa Hakananai'a and the Orongo 'Doorpost.'" *Journal of the Polynesian Society* 123 (4): 383–98.

Viaud, Louis-Marie-Julien [Pierre Loti]. 1872. "Journal d'un sous-officier de l'état-major de *La Flore*." *L'Illustration: Journal Universal* 154: 133–34.

Viaud, Louis-Marie-Julien [Pierre Loti]. 1873. "Expedition der Fregatte 'La Flore' nach der Osterinsel 1872 Aus dem Tagebuche des Schiffsfähnrichs." *Globus* Band XXIII. Nr. 5: 65–68.

Archives and Special Collections

Agassiz, Alexander. "Notes from the USFCS *Albatross* on Eastern Pacific Expeditions." Special Collection MCZ.17 (1913: 425–30). Cambridge, MA: Harvard University, Museum of Comparative Zoology Library.

Gordon Cumming, Constance Frederica, 1870s-1880s. Album. Photographic Collections Original, access no. Z 4152, ID P.99004.GCUM, ref. A.169.GCUM. Cambridge: Museum of Archaeology and Anthropology, University of Cambridge Museums.

Mückler, Hermann. 2016. Draft English translation from the original German (Mückler, 2015) of pp. 164–66 provided by the author and titled Tattoosknoche_164_166.pdf. Copy on file, Easter Island Statue Project Archives (Misc. Research and Correspondence), Santa Monica, CA.

Pinart, Alphonse Louis. Collection on the linguistics, ethnology, and geography of the Pacific Islands and Australia, 1877–85. Correspondence and papers, 1870–95: BANC MSS Z-Z 17, "Fragmentary Diaries" 3–14, including Tahiti and Easter Island (January 18–April 26, 1877), and 2 vols. "Vues et inscriptions de l'île de Pâques" by P. Loti. Berkeley: University of California, Berkeley, Bancroft Library.

Stolpe, Hjalmar. 1883. *Påsk-ön I Stilla oceanen: Anteckningar*. Stockholm: A. L. Normans. MS reproduction: TS of a holograph translation at Pac. EI 1. Bishop Museum Archives.

Adrienne L. Kaeppler is curator of Oceanic ethnology
at the Smithsonian Institution in Washington, D.C.
She has conducted field research throughout Polynesia,
focusing on Tonga and Hawai'i. Noted for her work on
collections from Cook's voyages, she continues to focus
on connections between social structure and the
visual and performing arts. She is presently engaged in a
large-scale project with Polynesian community scholars and
conservators focusing on Polynesian barkcloth collected
during the United States Exploring Expedition (1838–1842).

Jo Anne Van Tilburg is an archaeologist and director of the
Rock Art Archive, Cotsen Institute of Archaeology at UCLA.
She heads the Easter Island Statue Project, an inventory
and analysis of over 900 Rapa Nui statues (*moai*).
Her research addresses the integration of symbolism
and structure and the complex ways in which humans
employ social practices and ancient aesthetics to
alter, shape, and impact the natural landscape.

THE ICONIC TATTOOED MAN OF EASTER ISLAND
AN ILLUSTRATED LIFE

This volume is the first in a new series of illustrated
small books dedicated to Rapa Nui arts.

PUBLISHED IN 2018 BY

MANA PRESS

ALL RIGHTS RESERVED

COPYRIGHT © MANA PRESS 2018

WWW.EISP.ORG

Mana Press titles are distributed worldwide in association with
Floating World Editions and may be purchased from your local
or on-line bookseller. For trade discounts please contact our
distributor at 800-252-5231 or ussales@accartbooks.com.

ISBN 978-1-7324952-0-3

LCCN 2018907464

Designed and produced by Barbara Pope Book Design
Printed in China

MANA PRESS